Late Sickert

Paintings 1927 to 1942

Hayward Gallery, South Bank, London
18 November 1981 to 31 January 1982

Sainsbury Centre for the Visual Arts,
University of East Anglia, Norwich
2 March to 4 April 1982

Wolverhampton Art Gallery
12 April to 22 May 1982

Arts Council
OF GREAT BRITAIN

Copyright© the authors and the Arts Council of Great Britain 1981

ISBN 0 7287 0301 7 (softback)
ISBN 0 7287 0302 5 (hardback)

Catalogue edited by Marianne Hollis

Arts Council exhibition assistants: Julia Baxter and Louise Doey

Designed by Ken Garland and Associates

Printed by Graphis Press Ltd
A list of Arts Council publications, including all exhibition
catalogues in print, can be obtained from the Publications Officer,
Arts Council of Great Britain, 105 Piccadilly, London W1V 0AU

Contents

Front cover:
Detail of *The Servant of Abraham* 1929 No 2

Preface

This is the first time that the late work of Sickert has been gathered together on a significant scale. Our intention has been to create an opportunity for the re-appraisal of paintings which although popular and highly regarded at the time they were first exhibited, have subsequently been seen, in some quarters at least, as a sad end to the career of a great English artist. Needless to say this is not the view of those who have helped us in organising the exhibition, specifically Dr Wendy Baron, Frank Auerbach and Richard Morphet who have constituted an informal but most effective committee of advisers.

We have limited ourselves to the last fifteen years of Sickert's life, taking 1927 as our starting point both for the convenient biographical fact of Sickert's marriage to Thérèse Lessore and the more pertinent reason that this date marks the commencement of the series of Echoes, a type of late Sickert which has proved especially difficult for later generations to appreciate. We have also allowed circumstances, chiefly the accessibility of works, to dictate the selection rather than already formed taste, for the reason best stated in a remark of one of the organisers to the effect that it was important to show that the making of great pictures is not necessarily separable from the making of bad ones. We have therefore assembled as many pictures as we thought could properly be accommodated in the galleries. Only when they have been hung, a task for which we have had the assistance of Frank Auerbach, will it be possible for more general opinions to be formed about their qualities and their failures. In this way the exhibition represents an essential step towards a major presentation of Sickert's whole oeuvre, an exhibition which we hope will be staged in London before too long.

The case for Sickert's late work is argued with conviction in the catalogue texts by Helen Lessore, Frank Auerbach and Richard Morphet. These contributions were written independently of each other and differences in approach and emphasis indicate the complexity of the body of work which is their subject.

In our search for late Sickerts we have been fortunate to have the guidance of Dr Wendy Baron whose knowledge of the artist's work is without equal. She has catalogued the paintings with an admirable and thorough professionalism. Many others have helped us in our enterprise and we would particularly like to mention Mrs Helen Lessore, who, as well as writing in the catalogue, has drawn our attention to many important pictures; Dr David Brown of the Tate Gallery, who secured a vital loan which we had despaired of obtaining; Mr Geoffrey Parker, who drew our attention to the text by Denton Welch which is reprinted here by kind permission of David Higham; Mr Michael Parkin, for drawing our attention to the photograph of Sickert and Thérèse Lessore at Bathampton by Sir Cecil Beaton; Mr David Sylvester, Chairman of the Council's Art Advisory Panel and himself one of the first to write about the achievement of Sickert's late work, for much help and encouragement; both Christie's and Sotheby's, as well as a number of private galleries in London, for assistance in helping to trace pictures. But, of course, our major debt is to the lenders to the exhibition, both public and private, who are listed opposite.

Joanna Drew
Director of Art

Andrew Dempsey
Assistant Director for London exhibitions

Lenders

to the exhibition

Her Majesty Queen Elizabeth The Queen Mother 15

Aberdeen Art Gallery and Museums 102, 110

Mrs Valerie Bather 35

Belfast, Ulster Museum 103

Belgrave Gallery, London 60, 69

Dr Edwin Besterman, MA, MD, FRCP 87

Birmingham Museums and Art Gallery 98

Bolton Museum and Art Gallery 88

Bradford Art Galleries and Museums 52

Brighton, Royal Pavilion, Art Gallery and Museums 31

Bristol City Museum and Art Gallery 44

Cambridge, Fitzwilliam Museum 12

E Carew-Shaw, Esq FRCS 76

Edinburgh, Scottish National Gallery of Modern Art 57

Lady Elliot 14

Mr and Mrs Eric Estorick 1

Lord Faringdon 33

Mrs Constance J W Fettes 51, 116, 117

Mrs Kathleen Fisher 65

Cyril M E Franklin, Esq 18

Fredericton, Canada, Beaverbrook Art Gallery 20, 21, 29

Frost and Reed Ltd, London 105

Glasgow Art Gallery and Museum 13

R F Glazebrook, Esq 81

Mr and Mrs J G Glendinning 121

Government Art Collection 58, 68, 80, 113

M V B Hill, Esq 95

Hove, South Eastern Electricity Board 47

Hull, Ferens Art Gallery 74

Kircaldy Art Gallery 90

Leeds City Art Galleries 49, 91, 112

Leicestershire Museums and Art Galleries 67, 72

Liverpool, Walker Art Gallery 73

London,
Islington Libraries 43
National Portrait Gallery 4, 9, 22
Trustees of the Tate Gallery 2, 3, 23, 24, 25, 37, 41
University College London 36

Methuen Collection 8

Minneapolis Institute of Arts, USA 10

N R E Miskin, Esq 118, 119

The National Trust 16

New York, USA, The Museum of Modern Art 56

Odin's Restaurant, London 66

Oldham Art Gallery 104

Oxford, Visitors of the Ashmolean Museum 45

Mrs Suzanne Paisner 111

Peterborough City Museum and Art Gallery 106

Dr and Mrs Colin Phipps 53

Giles Playfair, Esq 39

Private collections 5, 7, 11, 17, 19, 26, 27, 28, 32, 38, 40, 42, 46, 48, 50, 54, 55, 59, 61, 62, 63, 70, 71, 75, 78, 82, 84, 85, 86, 89, 92, 93, 94, 96, 97, 99, 100, 101, 107, 108, 109, 114, 115, 120

Southampton Art Gallery 64

Stoke-on-Trent, City Museum and Art Gallery 77, 83

Major-General Sir John Swinton 34

Mr and Mrs David Tomlinson 79

The Welsh Guards, London 30

Worthing Art Gallery and Museum 6

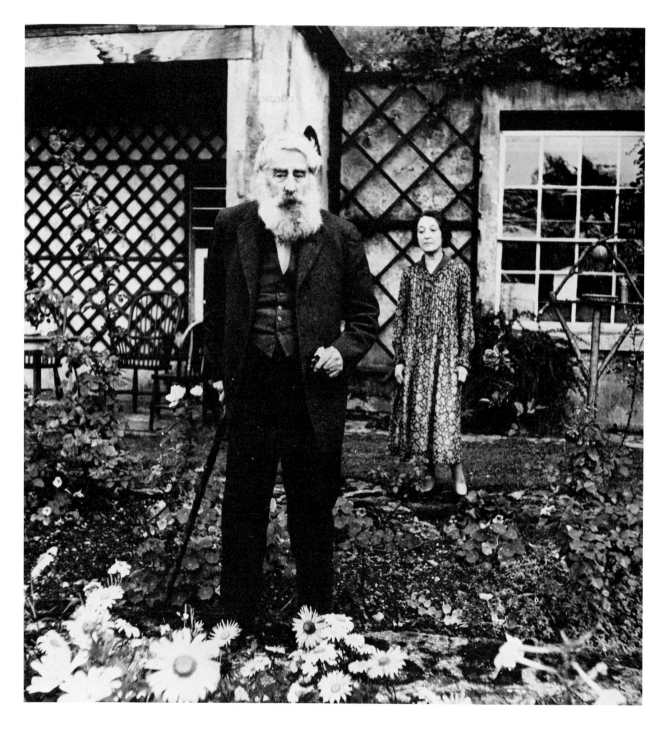

Foreword

Frank Auerbach

Rotten art and great art have something in common: they are both shameless. Sickert's paintings became more raw and curious as he grew older and it has been suggested that his later work was not his best. This exhibition is dedicated to the other possibility, which is: that Sickert showed himself, most clearly, in the last years of his life to be a great artist.

If one were to ascribe a development to him, one might say that Sickert became less interested in composition, that is in selection, arrangement and presentation, devoted himself, more and more, to a direct tranformation of whatever came accidentally to hand and engaged his interest, and accepted the haphazard variety of his unprocessed subject matter.

An active mind, if joined with a tragic sense of life, may make in the end for a sort of detachment. Sickert's detachment became increasingly evident in his uninhibited procedures. He made obvious his frequent reliance on snapshots and press photographs, he copied, used and took over the work of other, dead, artists and made extensive use, also, of the services of his assistants who played a large and increasing part in the production of his work.

But these interesting ways of producing paintings would have been, of course, of no interest if the resulting images had not conjured up grand, living and quirky forms.

Sickert and Thérèse Lessore at Bathampton in 1940. Photograph by Cecil Beaton, reproduced by courtesy of Sotheby's Belgravia

Late Sickert, then and now

Richard Morphet

A changed climate

Sickert has long and rightly been seen as an outstanding figure in the English art of his period; but influential opinion in the art community has viewed his late work as marking a sad decline. Till now, Sickert specialists and the taste of the times have combined to discourage, in practice, searching consideration of the character of this work. Thus despite the fact that the late paintings continue many central preoccupations of Sickert's earlier career, the unprecedented scale and concentration of the present exhibition reveal to us almost a new artist. For this reason the complexity of his late vision and practice might best be commented upon after rather than before they are exposed. Even before the exhibition opens, however, the changing climate of art and its appreciation in our own day enable us more readily to identify many of the richly rewarding characteristics peculiar to Sickert's painting after 1926.

Though controversial, Sickert's works of these fifteen years were generally well received at the time they were painted. He achieved then a greater popular success than had ever come his way before, and to the Press's related responses to his persona as a grand old eccentric and to his often sensational subject-matter was added the sincere esteem of a significant, if minority, portion of the younger generation of artists. The most obvious of these were the artists connected with the Euston Road School. But since Sickert's death the view of his late work that has dominated has been the dismissive one of some of his most prominent admirers, for example, Lillian Browse, organiser of the timely and important wartime retrospective held at the National Gallery when Sickert could still appreciate the accolade. In one of her two admirable monographs she writes of his 'tragic deterioration' after 1930, and of his 'collapse due to old age'.[1] Already in Sickert's lifetime Clive Bell described the Echoes as 'ridiculously feeble',[2] while twenty years later Michael Ayrton could still see the bright pictures of the 1930s as 'sad squeaks'.[3]

One might summarise the grounds on which Sickert's late work has been seen as a decline as being that his increased dependence on pre-existing ready-made source material (photographs and nineteenth century engravings) and emphasis on its 'mechanical' transposition onto canvas reduced the immediacy of his engagement with the subject and/or his ability to give life to his paint. Now, however, the perspective of time seems likely to lead to more general acceptance of the opposite view, persistently advanced by certain critics throughout the intervening period, namely that Sickert's late work was a remarkably original achievement of lasting value. One pointer towards this outcome is the recent belated response by the English art community to the emotional intensity and expressive 'rawness' of execution of the Germanic tradition in modern art. Sickert was steeped, to happy effect, in a French tradition of paint handling and of a certain telling restraint. Both these qualities continued to be important in his late work, but in it they were augmented by at least three characteristics which were unacceptable by the standards of a particular French-biased English appreciation of harmony and *belle-peinture* − a vigorous 'coarseness' of touch, an 'over-obvious' projection of the image, and alternating extremes (pictorially speaking) of drama and of 'dullness'. Despite the German element in Sickert's background it would of course be straining the evidence to suggest that these qualities in his late work attach him to German art of the period. It does however seem more than a coincidence that increasing appreciation of late Sickert should be occurring in parallel with a growing understanding of non-French earlier twentieth century painting (such as Hopper's, and the Neue Sachlichkeit) in which stringency of visual observation and intensity of psychological/emotional response to the subject are combined.

Perhaps still more significant of our understanding of

late Sickert is the deepening appreciation of those kinds of painting in which the combination of these two qualities is made possible by – and one with – a curiously vivid use of paint itself. A pointer towards this changing climate has been the appreciation of late Sickert by writers such as Andrew Forge and David Sylvester who, while having strong connections with Euston Road artists, have consistently identified also with the art of Bomberg and of Bacon. Though these two artists' views of late Sickert are not known to me, Bomberg (who had once been taught by Sickert) and Bacon are artists of exceptional distinction whose work, though strikingly different from Sickert's and from each other's, nonetheless has qualities in common with it which become increasingly apparent with the passage of time. In relation to late Sickert these artists' common ground and the receptiveness of the present climate are aptly focussed in the fact that this exhibition was proposed and is being hung by a painter, Frank Auerbach, whose work, along with that of several of his closest colleagues, is emerging into more general recognition simultaneously with the earlier tendencies mentioned above. These conjunctions make us aware that Sickert's late works are important antecedents in a continuing tradition in English art. It is a tradition which Sickert himself illuminated when he wrote as early as 1910 that subject and treatment 'are one, and that an idea does not exist apart from its exact expression! . . . The subject is something much more precise and much more intimate than the loose title that is equally applicable to a thousand different canvases . . . IF THE SUBJECT OF A PICTURE COULD BE STATED IN WORDS THERE HAD BEEN NO NEED TO PAINT IT' (Sickert's capitals).[4]

It is a commonplace that new impulses in art tend to throw fresh light (and appreciation) on the work of any important artist of the past. This happened to Sickert when the heyday of Abstract Expressionism brought a new responsiveness to the animated all-over surface qualities of his late pictures. In the 1960s it went still further, since late Sickert had undeniable features in common with Pop art, such as the blatant re-presentation on an enlarged scale and in vivid colours of images from the media, including those of stars of stage and screen and popular illustrations of humorous situations. Nevertheless the dominant taste of the 1960s and early 1970s was too much towards a cool, hard clarity of form and towards an iconic sense of image for the accompanying *complexity* of late Sickert to be appreciated, particularly in respect of the interdependence of the subtlety of his handling of colour and paint with his exceptional psychological acuteness. Since the mid 1970s, however, a climate has developed in contemporary art in which all the characteristics of late Sickert which made it most difficult for admirers of his earlier work to take (vigorous 'coarseness' of touch, 'over-obvious' projection of image, and extremes of pictorial drama and 'dullness') can be seen as strengths. This new climate even enables us to view the very features of his art which many have regarded as insensitive as, paradoxically, the vehicles of a special perceptiveness and subtlety.

This climate was suggested by the Royal Academy's controversial exhibition 'A New Spirit in Painting' (January – March 1981), which presented a novel – to Britain – international selection of contemporary painters who, like late Sickert and in many cases no less provocatively, are equally obsessed by vividness of subject in art and with drawing attention to the painterly processes involved in making images. Like Sickert these and many unrepresented artists working in a similar vein produce work which is also conspicuously decorative and allusive, and is sometimes nostalgic. Since they are consciously in reaction against the implied aridity of minimal and conceptual art, the following contemporary appreciation of Sickert's late work in relation to the vanguard of his own day strikes a familiar note. 'There is no necessity to enlarge upon the

tedium of many exhibitions of the present day. Quite often they show a high level of technical ability, but it is divorced from human content. The spectator wearies in the end of the continual display of intellectual exercise ceaselessly revolving upon itself . . . [Sickert's] is painting into which all possible interest is gathered, where each element of pictorial appeal is exercised at its highest power. The result is splendidly tonic, putting to flight the spectres of pedantry and invading the spirit with clarity, colour and joy. Such painting without tears is the finest entertainment, and that is what it should be'.[5] Although this is over-simple in its perception both of Sickert's art and of the avant-garde of its (or any) day, it is difficult to think of a period since Sickert's death when new art developments offer so close a parallel as they do in 1981. In today's controversial 'new image' painting, blatancy of both image and colour are so combined with a painterly emphasis and a focus on how a picture was executed as to provide a newly sympathetic context in which for Sickert's late work to be seen.

With these large-scale decorative figure paintings of the 'New Spirit' from Germany, Italy and America it would be as false as it was with Pop art to imply an actual equation with Sickert's work, produced fifty years earlier and drawing on a personal practice going back fifty years before that. But what is significant of the climate of appreciation for late Sickert is the unprecedented fact of their conjunction in a major 'barometer'-type exhibition with graver artists such as Bacon and Auerbach who are working more directly in Sickert's own tradition. In their handling of paint these disparate groups both display, like Sickert, a powerful directness verging on blunt impoliteness. For Bacon and Auerbach, as for Hodgkin (another admirer of Sickert's late work and 'New Spirit' exhibitor) this quality is a way of working, as Sickert did, within a long European tradition which the rich, ruthlessly summary use of paint by all four, realising and even flaunting the subject, significantly extends.

The freedom of late Sickert

If Old Master antecedents for the 'New Spirit' exhibition had been sought from earlier in the century it seems clear, therefore, that late Sickert would have been one appropriate choice. In this connection the selection of late Picasso as the exhibition's oldest master of the 1970s is suggestive. For a feature of the late work of both Sickert and Picasso, different though they were, is an assurance in the act of painting – the result of decades of experience – so great as to give their work exceptional conviction despite failing physical powers or any sense of personal insecurity.

A long-standing advocate of catholicity in art and supporter of jury-free exhibitions, Sickert was opposed (like the mercurial Picasso) to restrictive theories. One ingredient in his provocative choice of 'inartistic' subject-matter, 'banal' composition and 'coarse' paint treatment seems to have been the wish to assert the freedom of the artist and the importance of subject, in the context of the widespread contemporary preoccupation with formal purity and in reaction to the theories of Roger Fry. But the analogy with late Picasso also reminds us how often (as in the frequently-cited case of Titian) an increased looseness of touch marks the late work of artists to whom content is all-important, in such a way as, paradoxically, to increase their paintings' expressive effect. This was the case with Sickert. In his late works, as in Picasso's, a certain looseness allied to an authoritative, devil-may-care sense of freedom from others' rules enabled him to reveal his insights into art and life with a strange and personal intensity. If, as in Picasso, these are enigmatic and even more difficult than usual to convey in words, this may be because of the sheer directness with which improbable paint mark and uncomfortable image coalesce. With each artist's late work this conjunction was sufficiently new and distinct for a passage of time to be needed before there could be general recognition of its character as a main-

stream rather than an aberrant contribution to a great painting tradition.

Contrivance and control

By analogy, again, with Picasso, one should not mistake gestural freedom − the more wilful-seeming of Sickert's assertions of the individual mark − for a loosening of essential control. In each of his works Sickert seems to have conceived a clear and particular idea of colour, structure, observation and expressive content, and to have realised this with concentration and panache. Both artists saw style as the servant of meaning; in Sickert's late work switches back and forwards, for example between rectilinear severity and all-over fluidity, should not be seen as denoting lack of concern with making defined and particular statements.

The ingrained sense of control which in this, Sickert's loosest and superficially most 'disordered' period, was as ever at work can perhaps be related to the strong feeling for architecture which runs through all his phases and which recurs here in his pictures of Bath, of the Porte St Denis and of Temple Bar. Sickert always relates buildings to their settings, and establishes in their stability a firm counterpoise to the human flux around them. Dwelling on the way they stand in space, their facades or ornamentation catching the light, he sometimes endows them with almost psychological presence. The stress Sickert himself laid on a commercial motivation and on an almost mischievous unpredictability has combined with the unserious character of some of his images in terms of the art of his day to mislead some writers into detecting a throwaway quality in his late work. Objectively viewed, the pictures themselves refute this interpretation.

Sickert's intellectual control, even when at his most instinctive, can be seen in his insistence on the import-

ance of economy. He was opposed to painting from nature partly because it cluttered a picture with unnecessary detail. He worked towards a definitive statement of a subject which, though vitally dependent both on the vividness of the first impression and on the liveliness of the paint marks which gave its final form, was in essence carefully contrived and usually sternly selective. He considered that only by its being literally a discipline could painting achieve liveliness and truth. In his own words 'Economy of means is a sign of the greatest craftsmanship in art. The finest literature is that which expresses most in fewest words, and the greatest paintings express most with the minimum of substance. One of the delights of art is the joy of seeing effect produced with an economy of means. Quality in paint results from a natural gift together with study and practice. These will give a nonchalance, a looseness, a rapidity, which in themselves are of great beauty'.[6] A Sickert painting was therefore a work of both compression and contrivance. Photography was a vital aid in this process. As he wrote in 1924, 'the consequences of the invention of photography are throwing their weight in the scale against what was called "realism" . . . *"On ne donne l'idée du vrai",* Degas was fond of saying, *"qu'avec le faux".* Painting is an art and that is to say that it is artificial.'[7]

In the same statement he praised Veronese and Reynolds for the care with which they prepared their work through stages. The startling directness of image in many late Sickerts, with their first-sight impression of having been transferred straight from the public presses, should not, therefore, allow us to forget the careful preparation and the reliance on system which led towards and underpinned the final statement, for all its immediacy. It is in this degree of contrivance leading to a painting immediate and public in its accessibility yet ambiguous in its expressive content that one of late Sickert's conections with Pop art lies. In terms of the process by which pictures were produced, Sickert is

noted for having 'depersonalised' painting. His rejection (again like the Pop artists) of the 'artiness' inherent in painting from nature was expressed both in his reversion to a studio system with much of the preparation undertaken by assistants and by the delight he took in the efficient production of recognisable, saleable images which met a public demand.[8]

A lone individual

The workmanlike tone which suffuses Sickert's late work in these two ways is an important component of their expressive character. It is augmented by the frequency and degree of Sickert's exposure of the squaring-up grid in the finished painting, inevitably calling to mind the practicality of his procedure (even though it works in another way simultaneously because of Sickert's tendency to make the interplay between grid and paint marks an aesthetic subject in its own right).

This tone coexists, however, with a contrasting emphasis which one can only call existential. Sickert's very insistence on systematic preparation made his own decisive marks in completing the painting a climatic act. In the traditional studio system this had of course always been the case. But the freedom of gesture and of colour-choice introduced into art from the late nineteenth century combined with Sickert's conscious participation in a grand painting tradition going back several centuries earlier to make more noticeable both the magisterial and the idiosyncratic aspects of his touch. Thus in Sickert's more freely-painted late pictures objectivity and self-expression are intriguingly combined. The latter characteristic is extended in the prominence of his late signatures and inscriptions, which are often startling in boldness, letter form or extent.

Andrew Forge's observation that 'For two years he was an actor. And being an artist was literally the performance of a lifetime',[9] can both be applied to the more bravura side of his painting technique and related to the theatrical way he visualised either a situation or (particularly) the human individual. The most obvious instance of Sickert's obsession with the isolated individual is his repeated representation of himself. Conspicuous by their absence are introspective self-portraits. Instead Sickert always projects himself as a character or in a striking situation. Whether we take their tone seriously or humorously, most of Sickert's many late self-portraits are distinctly uncomfortable as projections of human situation. These images emphasise rather than accept the pathos of old age, and treat of illness, suffering and tribulation. Sickert also sees himself as a gambler, and as 'A Domestic Bully'. Where not actively disturbing in these ways the late self-portraits are often enigmatic, as in the paintings showing Sickert with a blind fiddler; in the doorway of his wine cellar; or lying sailor-capped in a library, overseen by Thérèse. Sickert's secretiveness, possibly a means to maintaining his independence as an artist, has often been remarked; whether or not this was a factor, the image he paints of himself suggests a sense almost of alienation, which the very restlessness and diversity of his guises compounds. Indeed one reason why it is impossible to separate Sickert's personality and behaviour (whether lovable or tragic, dedicated or bizarre) from his paintings is that in both their execution and their content he himself made the two inextricable. Related examples in subsequent English art are easy to identify; the same is true when one considers the strong cumulative sense of the isolation of the individual conveyed by Sickert's portraits of contemporaries, along with so strong a projection of the presence of each sitter that the viewer has a heightened feeling of encounter or confrontation. For all the obvious differences of scale, facture and painting method, a certain parallel with the work of Giacometti is therefore not invalid.

A dramatic sense of life

As a former actor, Sickert would be well aware of the traditional loneliness of the actor realising a role on stage. This may have been one element in his preoccupation with images drawn from contemporary theatre scenes in which, in his late phase, he usually devoted more attention than in his earlier theatre works to the actor as opposed to the setting as a whole. But whether in feeling or conception, or both, Sickert's late works are dramatic in a more general sense. The contrasting identities of the self-portraits deliberately create a mystery as to the nature of the real Walter (or Richard) Sickert, and this is augmented by his dramatic shifts in subject, between extreme mass-circulation-linked contemporaneity and nostalgic recreation of an earlier era. A parallel puzzle is the contrast between pictures with encrusted paint in glowing colours, others, more thinly painted, with bold and surprising colour-oppositions, and still others of an unusual evenness of emphasis and homogeneity of tone. Thus the very form and sequence of Sickert's late pictures has a quality of unpredictability and showmanlike self-awareness. The ways in which he presented the human image tend to maximise the dramatic impact of an individual personality. Sometimes subjects' heads virtually fill the canvas area, as in *The Servant of Abraham* or *King George V and his Racing Manager*. In other works (such as the Lumsden, Castlerosse, Aloisi, Macdonald, Faringdon and Edward VIII portraits and the self-portrait in the National Portrait Gallery) affinity between a full-length figure and an unusually tall, thin canvas format gives a sense of immediacy in a different way. Sickert frequently made theatrical use of the fall of light, and another effective means of concentrating attention on the sitter's presence was to isolate the head, in close-up, against an animated all-over back-drop.

Notably absent are still-lifes or interiors without people, for neither of these genres offered the human interest which was all-important to Sickert. Even the calmest of his street scenes is presented as the natural location for the kaleidoscope of the passing scene. He showed a special liking, however, for settings in which life is unusually colourful – racecourses, pubs, casinos, theatres. And he had a marked interest in striking *situations*, such as emotional dramas or the moments of arresting arrivals (Edward VIII; Miss Earhart; *The Miner*) or departures (*Pimlico; Suisque Praesidium*). In general terms all these interests are already apparent in Sickert's work from long before 1926. Nevertheless in terms of subject, the world presented in his work from the mid 1920s is noticeably different from that made familiar before. It is more dramatic, more open, and more filled with contrasts and puzzling emotions. His dramatic sense is seen in the frequency with which, as suggested earlier in respect of his dramatisations of his own lot, situations evoked in the late work involve disillusion, disharmony, downfall or death. As emphasised below, Sickert had an infectious relish for the pleasures of life. Nevertheless the late work, taken as a whole, of the painter who earlier (for whatever reason) had titled paintings after the Camden Town Murder, and now, for example, included a high proportion of tragedies among the plays which feature in his theatre scenes, is tinged by a sense of the latency of this recurring preoccupation with the darker side of experience. This was one component in his richly complex view of life.

Importance and projection of the subject

Though Sickert had always had an eye for the colourful situation, the human angle, his late works seem to show an enhanced (even though far from exclusive) responsiveness to extremeness of situation, whether humanly or pictorially. In a typically Sickertian paradox, this emphasis increased in tandem with the many devices he employed to show that an image, however emotive, was among other things an arrangement of abstract shapes

and that its transposition onto canvas was in many ways a dispassionate procedure. But the view, strongly held by some writers on Sickert, that in the late work his long-remarked attitude of detachment extended beyond the actual painting process to a personal lack of interest in subject or in ensuring that the painting should communicate it strongly, does not stand up to examination.

That this is true is shown in his attitude to the photograph as source. By 1926 Sickert had moved a long way from the position he expressed when he wrote in 1893: 'In proportion as a painter or a draughtsman works from photographs, so he is sapping his powers of observation and of expression. It is much as if a swimmer practised in a cork jacket, or a pianist by turning a barrel-organ'.[10] In his late period Sickert was not only using photographs (which he had been doing for a long time, and indeed for much longer than this statement of 1893 might suggest[11]) but, as in *Gwen Ffrangcon-Davies as Isabella of France,* was boldly asserting in the finished work the photographic nature of his sources. Moreover it was not just a question of choosing as his source a photograph which happened to come to his attention. As discussed above, his acts of selection show distinct thematic preferences. But furthermore 'the shot had to be just right before he would use it',[12] and for many of his theatre paintings he brought along his own photographer so as to achieve the effect he sought, rather than relying on publicity stills.[13] The photograph certainly appealed to Sickert because of the way it froze the subject and brought out often striking and unexpected abstract values in the motif. But the photograph was, no less, a means of capturing and transmitting the subject in more essential, more concentrated, form, confusing detail being cut out and the innate drama of the scene intensified. It was a means for Sickert of going beyond realism to something which, though suffused with awareness of the actual circumstances of the source, would achieve a greater expressive fullness.

In part this fullness was the result of Sickert's special gift for combining into a single experience two distinct components: a heightened awareness of the factuality of the motif (as consisting of particular material phenomena) and the expression of feelings or an atmosphere peculiar to the person or scene depicted. Some of Sickert's subjects were, at least in their source-form, distinctly inconsequential. Yet typically of his dramatic or literary bent he transmuted them by paint into statements at once poetic and suggestive. Paradoxically he was able to achieve this effect without losing the sense of the bald actuality, even ordinariness, that may have been present in the original document;[14] indeed the projection of such a quality was itself an ingredient in his expressive effect. But having selected a source image, Sickert contrived by his selection of colour, focus and emphasis to open it up into a convincing, live environment in which the viewer could find his way about, both imaginatively and topographically. 'Minor' details, such as chairs or balustrades, are often made features of greater interest than in the original source, emphasising the fact that a late Sickert is not just an image snatched and stamped out once again, but the invention of a particular world. Indeed Sickert's arbitrary though purposeful use of colour should alone dispel any idea that his transpositions of his sources were literal repetitions; he developed the original in the direction he chose, in the process establishing points of attention in often quite different places.

Sickert's role in editing and selectively intensifying his source is even clearer in the Echoes than in the works based on photographs. Here he can be seen variously picking out particular details for sharper examination or unifying the pictorial scheme into a more continuous, all-over surface than in its nineteenth century engraved source. The accuracy of Virginia Woolf's comparison of Sickert with Dickens, Balzac, Turgenev and other nineteenth century authors[15] is here particularly apparent. Sickert himself drew an analogy with literature when he

said of contemporary painting 'Much of our modern landscape has an imported air, and the figures are tucked away in corners. They are seldom DOING SOMETHING in the landscape. Instead, the two elements should be knit together both psychologically and pictorially. The novelists know how to use landscape as part of the things that people feel and do'.[16]

To the observant, retentive and nostalgic Sickert, born in 1860, the contemporary social scenes, engraved in the same period, which were his sources for the Echoes, must still in the 1930s have conveyed a vivid sense of reality. No doubt this was compounded rather than weakened by increasing age, the effects of which on the relative vividness of distant and recent memories are well known. It is difficult to agree with Lillian Browse, writing of the Echoes, that 'trying to recapture the spirit of an earlier era whose story-telling morality was by then out of date, they are false in sentiment [and] relatively poor in quality'.[17] They seem quite extraordinarily to convey the flavour, and certain types of situation, of their original time and place. Indeed they do so as well (by very different means) as the sources from which they are developed and better than Orchardson was able correspondingly to do for a slightly earlier period. In view of Sickert's intense identification with illustration as both impulse and tradition, this is not surprising. He was able to work from within (and to preserve) the spirit of his sources, while adding something quite other. What is so surprising is that this important addition should have been vitality in the quite different terms of ambitious painting, yet that Sickert should have managed to fuse this quality, without strain, with the authentic spirit of his illustrational sources. At the same time the Echoes make us aware (as Sickert's treatment of contemporary subjects does in other ways) of a preoccupation running through his late work with the mystery of time, the enigmatic relationship between 'then' and 'now'. And they are evidence of his fascination with the *life* of a

vivid image, with its capacity both for survival and for revivification through the very process of translation, retaining its essence despite radical alterations.

The life of paint

Both the colour and many of the subjects of the Echoes have a hedonistic character, in marked contrast to the disturbing side of Sickert's vision commented on above, though they are far from contradicting it. Just as Sickert brilliantly recreates the animation of a past milieu, so his late theatre scenes capture the artifice and magic of the stage. With the increased broadness of Sickert's painting technique at this period there is sometimes a curious and effective parallel between his canvases and the look of scene-painting for the stage, particularly in the backgrounds (almost the backdrops) he introduces as independent though integrated elements in portraits. His astonishing painting *Entente Anglo-Russe* unites his interest in the colour of the stage with the Echoes. Hectically painted and derived from Cruickshank, it represents, almost caricaturally, some twenty ballet dancers arranged in a pyramid. Several brandish scythes, while sheaves of corn are held aloft by some and worn by others. Truly weird in the context of the sensibility of its own period, such a picture anticipates prominent currents in painting today. A preoccupation with liveliness links scenes like this and the paintings of ranks of chorus girls with Sickert's genre scenes, both Echo and contemporary.

Adjectives such as dull, coarse or strident are often applied to the colour or brushwork in late Sickert, but ideally they should be enclosed in inverted commas. Though they are useful, their principal value is in comparing Sickert's practice with that of his contemporaries and with their standards of expectation. For in his late period Sickert in fact displayed, albeit in a broadened manner and while encompassing greater extremes of

expression, the same natural grace that characterises his work at all stages. His handling of colour and brushwork, like that of character and atmosphere, continued also to be distinctly subtle, a point more readily appreciated from the perspective of the 1980s. For all their remarkable directness of impact (and indeed of touch) by the standards of their day, Sickert's images, far from being straight copies on a larger scale, were built up by a sequence of paint marks and deposits which, from an early stage in each work, set up an internal dialogue of a very personal liveliness and beauty. In this dialogue visual and textural elements of every kind were brought into play including, as has often been pointed out, the underlying *camaieu*, the scaffolding of the squaring-up grid and the by now often ostentatiously rough weave of the canvas itself. Sickert painted both thinly and thickly. Deposits of paint which appear, not even at particularly close range, to be independent of descriptive function, and which lie discrete against the highly contrasting texture of the hessian support, are among the types of mark through which Sickert's late paintings give a sense unusually strong, even for their sophisticated day, that painting is the art of laying substances on a flat surface. In Sickert's hands such effects contribute excitingly to the poetry rather than the theory of painting. It is another of his paradoxes that while vigorously in reaction against the aestheticism of his master, Whistler — a reaction which his late works exemplify as strongly as any before — Sickert extended to the end Whistler's emphasis on sheer quality in paint.[18] One of his last works, *Temple Bar,* is one of his most richly-textured, and is at the same time a typical example of the mysterious internal subtleties of colour of which he continued to be the master. Sickert's mastery also enabled him to combine different methods with great originality. Some pictures are like anthologies, within a single work, of different ways of applying paint.

It is interesting that Sickert should have had a friendly association in the 1920s with the Sitwells' Magnasco Society. Their pioneering revival of interest in a strange and atmospheric area of past art, of which Magnasco with his free-flying brushstrokes and dramatic lights was a part, seems to connect with the direction of Sickert's own later work. For he developed a vision in which colour and touch, while crucially serving a painting's subject, seem directly expressive, in themselves, of something mysteriously personal both in its heightened view of life and in the cavalier assurance with which paint is set before us in often improbable ways.

Late Sickert and the art of his time

Sickert's authority with colour in his last fifteen years was frequently remarked on at the time. One hopes that the present exhibition will re-establish his importance for English inter-war art in this respect. One reason for the temporary eclipse of such an awareness is that by comparison with contemporary English artists famous for their colour, such as Matthew Smith, Sickert as a colourist does not have a single clear identity. It would be difficult, for example, to imagine a greater contrast in colour approach than between *Temple Bar* and *The Beautiful Mrs Swears*. Indeed in terms of subject-matter and composition, no less than of colour, the very range of Sickert's late expression is one factor which has made this period of his work elusive (and hence often omitted) historically. This exhibition should demonstrate its real unity as well as its stature.

In Sickert's late art this extraordinary range, which relates to its richness of meaning, helps account also for the complexity of his affinities with the art of his contemporaries and immediate successors. Though their subjects and their sense of structure could hardly be more different, there is a certain parallel with late Monet in the new emphasis on encrusted surface deposits, 'autonomous' marks and strength of colour —

all, nevertheless, in the service of subject – seen in the late work of both artists. A parallel might be drawn with the late work of Bonnard on similar grounds, and with a greater closeness deriving from their nearer age and the stronger formal interest in their work. The late work of both artists, conspicuously including figure subjects and self-portraits, seems concerned with the mystery of time and a kind of tragic resignation, obstinately and tellingly alive to the end, however scribbled or staccato the touch might become. It has been claimed[19] that Sickert's Echoes fitted readily into the decorative taste of the 1930s. Far though they are either from the hard clarity which found such favour with the vanguard of the period or from the generalised classical subject-matter so fashionable in the painterly decorative work of Duncan Grant and Vanessa Bell, this may be true.[20] The intense admiration felt by the Bloomsbury artists for Sickert lay, however, not in the field of decorative art but in his unique combination of professionalism in technical matters, dedication to the art of painting through all the eccentricities of his personal circumstances, and obsessive concern with subject however startling its identity. With Roger Fry, who died in the middle of Sickert's late period, he always had a relationship at once combative yet friendly and mutually respectful. While Sickert vigorously rejected the insistence on theory which he and others associated with Fry, Fry's own practice as a painter, particularly in his later period, shows a concern with observation and with humanity of subject, and a quiet ease and liveliness distinct from the dominance of theory, which form a link with the more sober side of Sickert's late work and help explain the interest of the Euston Road painters in both artists.[21]

At the beginning of this period T W Earp had described Sickert as 'one of the few living artists who enjoy and exploit to the full the great adventure of the purely technical side of painting, the effect of colour placed against colour on a carefully prepared ground'.[22] Although the Objective Abstraction painters of the mid 1930s did not stress colour, Sickert's exceptional concern with paint as manipulated substance was very close to their interests. In 1934 W W Winkworth reported Moynihan as admiring Sickert as much as Picasso and described how he pointed out 'subtleties in Sickert's use of his medium which I should never have noticed for myself . . . a broad line of thick mauve impasto . . . the actual dry roughness of the paint itself'.[23]

It is true, as Denys Sutton has pointed out, that in making increased use of photographs Sickert 'was steadily feeling his way to a more abstract conception of art'.[24] But however abstract his works became, their thrust remained insistently figurative. Thus the link with Objective Abstraction, though revealing, is less significant than that with Euston Road. Like Sickert the artists of this group favoured pictures which answered ordinary needs rather than those of a critical avant-garde. They could admire in Sickert his workmanlike technical practice, his continuation of studio tradition, and his concern with intelligibility. A related shared instinct was aversion to fantasy. Whatever alterations Sickert might make (to striking expressive effect) in colour, points of focus or enlargement of scale, one of the foundations of his sensibility was a concern with the sheer visual facts of the act of observation, whether by the camera or by his own eye. Even though he created a kind of magic from these facts, a down to earth quality was therefore central to his art. This acceptance of reality was shown partly in a very un-Euston Road choice of images startling in their dramatic character and exotic colour. But no less persistently Sickert selected subjects that were equally unconventional through the extreme degree of their ordinariness. In both cases a kind of disinterested objectivity was at work, alongside (paradoxically) the deep involvement apparent in Sickert's persistent curiosity about the sheer particularity and human interest of life. Just as in painting the Echoes Sickert got under the skin of the

aspects of mid-nineteenth century society he represented, so he insisted that a sense of contemporary reality should pervade artists' response to inter-war England; he even urged them to see the beauty inherent in ugly modern structures.[25] Part of his appeal for Euston Road must have lain in the strange combination of his acceptance of the contemporary (perfectly consistent with interests like Coldstream's in documentary film) with his incarnation of tradition. The example of Degas was important for Euston Road; Sickert, who had known Degas, never ceased to reiterate his precepts, whether in conversation or in aspects of his own practice. Moreover by the late 1930s when the Euston Road sensibility was decisively formed, the most pyrotechnic aspects of late Sickert in terms of colour and dramatic impact were being succeeded by a revived emphasis on sobriety of both subject and hue. The late Bath local townscapes and domestic subjects which, perhaps through the increased role of assistants, compound this sobriety with a renewed prominence of the 'impersonal', almost 'mechanical' aspect of Sickert's paint handling, have obvious points in common with Euston Road.

Here as in other comparisons, Sickert cannot, however, be neatly tied down within an English context, and this despite his own insistence in the late period on the need for artists to paint the life of their own country. Important though sobriety was for Sickert in several ways, understatement is not a hallmark of his work. In many ways the quality which seems to mark him off from most of his English contemporaries of all generations is boldness of conception − rising at times to a real grandeur of expression − in combination with striking projection of subject and projection of his own extraordinary personality.[26] This fullness in his art transcends an English context and relates it to more ambitious aspects of the European tradition.

An admirer of Millet and Courbet, Sickert was only seven years the junior of van Gogh. He shared the preference of all three for subjects drawn from real life. As he wrote in 1908 in criticism of Whistler: 'Taste is the death of a painter. He has all his work cut out for him observing and recording. His poetry is in the interpretation of ready-made life'.[27] Like all these artists, Sickert in his late work drew on pre-existing popular visual source-material, actually sharing with van Gogh an interest in Victorian magazine illustrations of the contemporary scene. In many of his late paintings the directness of Sickert's paint handling − a kind of sensuous roughness − links his work with theirs and with that of his near-contemporary Munch. These comparisons with painters re-emphasise the parallel validity of Virginia Woolf's association of Sickert with great nineteenth century novelists. They clarify also, however, certain major differences between Sickert and these other painters, for example the absence from Sickert's work of a strong symbolic ingredient (here his relative detachment is immediately apparent) and the degree to which, for any of them, Sickert's intermittent involvement with the world of glamour, wealth and artifice is inconceivable. This last subject is, however, encompassed in the work of Beckmann, who despite differing from Sickert in his sense of myth, archetype and symbol, is linked to him in seeing life as a human comedy embracing delight, decadence, tragedy and a sense of transitoriness. A further link between Sickert and van Gogh, Munch and Beckmann is the frequency with which all these intense observers of the human scene painted self-portraits, often uncomfortable in feeling and restlessly visualising themselves in a variety of situations. It is unavoidable that one should see Sickert as significantly linked to nineteenth century French painting, but these comparisons should indicate the oversimplification that is involved either in seeing his French links too dominantly in terms of Impressionism and Intimisme or in viewing his place in the European art of his day in an exclusively Anglo-French context. As usual in Sickert the position is more

complex and elusive.

In his late art, Sickert made greater use of large scale, bright colour and popular subjects. This art was probably addressed to and certainly reached a wider public than his work had done before. He was a sensitive and sophisticated artist and it is therefore possible, without suggesting any conscious connection, that an element in this change was a response by Sickert to the same complex currents which helped produce the contemporary public-orientated art (itself of contrasting kinds) of Mexico, the USA and Léger. Indeed it is reasonable to suppose that one motivation underlying some of the most striking features of Sickert's late art (such as increased scale, boldness of image, cheerfulness, uningratiating frankness, and his pictures' very ambiguity of meaning) was his perennial sensitivity to the mood of a period. In the 1930s all these features were very 'modern' and retained this quality despite coexisting easily, in Sickert's hands, with quite distinctly-derived elements such as his homage to the great Venetian colourists.

Those who consider such comparisons absurd will be even more offended by mention of Sickert in connection with Abstract Expressionism and Tachisme, the early formation of which tendencies coincided with his death. But commentators on his retrospective in 1960 remarked how informal abstraction (to which England had recently been introduced) enabled Sickert's late paintings to be seen in a fresh and flattering light. This was because he built up his image in a series of 'touches' which to a surprising degree continued to declare their autonomous abstract reality. This effect was enhanced by the larger scale of many of his late works, a factor which recalls their 'existential' character described earlier. A Sickert painting could now be read as the record of a highly personal and concentrated action in which painter confronted canvas. For all the precise mapping undertaken in the foregoing stages, the crucial last stage which gave the painting its essential form was both (in its sudden 'realisation' of the subject) an act of discovery and (in the gestural emphasis on unique autograph marks) an act of personal revelation.

This observation has to be qualified the larger the role of Sickert's assistants in a picture's final form, and in any case if carried too far the comparison begins to sound strained; but it still contains a kernel of truth. For an artist of Sickert's generation and ingrained habits, the terms in which any major new impulse within Western art was reflected during his late years were naturally so dissimilar as almost to be different in kind. Moreover a comparison with Abstract Expressionism underlines the sense one already had in relation to earlier modern art, of a certain limitation on Sickert's expression resulting from his unconcern with any profound symbolism. Nevertheless an artist of great sensitivity cannot help but respond to latent currents of his day, and one of the astonishing features of Sickert's late work is the sense it gives of renewal, of range, and of a degree of freshness in terms of the art context of its time which are remarkable in one of his age. The point is not so much that his art was 'advanced' as that its nature was complex not only intrinsically but also in terms of its period.

It is difficult to avoid seeing Francis Bacon as in many respects a direct heir of late Sickert. Unlike Sickert's, his work reflects the experience of Surrealism, is integrally autobiographical in an even more thorough degree, and has a rawness of both facture and feeling distinctive of a later period. But both artists, while extending a long tradition of ambitious European figure painting, take extraordinary risks, both draw heavily on pre-existing sources in which they respond to the revealing accidents of the frozen moment, and both observe human behaviour with a strange combination of almost clinical detachment and intense psychic involvement. Both make paintings which are themselves situations, the image compelling-to-disturbing and the paint exactly apt

yet having a quality so personal as to be difficult to explain. These two elements are locked into a precise relationship with a life of its own.

A rich paradox

Perhaps Sickert will remain always an enigma. The effectiveness of his late work often lies in the way he makes it embody, simultaneously, what one would have thought were mutually exclusive approaches; and ones, moreover, which are each taken to an extreme. The standard bearer of tradition, he made pictures which still seem startlingly modern. Concerned to demystify painting, to subject it to a system, he is nevertheless notable for his compellingly individual use of paint and for the mystery with which he imbued scenes and subjects however 'obvious' in origin. Immediacy of inspiration, running sometimes to a riotous exuberance of colour and form, was offered on equal terms with dry, sober yet expressive transposition. He presents life with an air in which amused relish, dispassionate yet restless and driven curiosity and a sense of grim awareness are strangely combined. Forge is one of many writers who in discussing Sickert keep coming back to the word 'paradox'. Describing the Glasgow portrait of Hugh Walpole he speaks of 'this paradoxical combination of roughness and accuracy, breadth and detail', and states 'this paradox — of abstract, almost meaningless paint and a sharply dramatic total effect — is typical of Sickert; it is his central characteristic.'[28] In an unusual degree a painter's painter, late Sickert yet brings out with uncanny skill the human vividness (both outer and inner) and the sense of place and time which ensure his works a much wider response. It is the fullness of his art which we celebrate, as we continue to discover it.

Notes

1 Lillian Browse, *Sickert*, 1960, p.50.

2 Clive Bell, 'Sickert at the National Gallery', *New Statesman and Nation*, 6 September 1941.

3 Michael Ayrton, 'An Obscure Person', *New Statesman*, 28 May 1960.

4 'The Language of Art', *The New Age*, 28 July 1910. A longer extract is quoted in Robert Emmons, *The Life and Opinions of Walter Richard Sickert*, 1941, p 263.

5 T W Earp, 'Richard Sickert: English Echoes', *Apollo*, Vol 13, June 1931, pp 344-347.

6 From Sickert's lecture 'Straws from Cumberland Market' 1923-4, summarised in Emmons, op cit (p 247).

7 From Sickert's article 'The Royal Academy', *The Southport Visitor*, Spring 1924, reprinted in W H Stephenson, *Sickert. The Man and his Art. Random Reminiscences*, 1940 (p 27).

8 cf Andrew Forge, 'The Confident Artist', *The Listener*, 16 June 1960, pp 1051-3.

9 Ibid.

10 'Is the Camera the Friend or Foe of Art?', *The Studio*, Vol I, June 1893, pp 96-102. Sickert's reply to this question, printed with those of many other artists, read in full as follows:
'In proportion as a painter or a draughtsman works from photographs, so is he sapping his powers of observation and of expression. It is much as if a swimmer practised in a cork jacket, or a pianist by turning a barrel organ. For drawing, which should express three dimensions, is substituted a kind of mapping, and colour is simply non-existent. *Coelum, non cameram mutat*, as Mr. Whistler recently said of a much-travelled photo-painter. It would be well if the fact that a painting was done from or on a photograph were always stated in the catalogue. A serious critic should be able to detect the most blatant cases for himself. It is extremely misleading to the public and to young students to find work of that order critically compared to works of pure craftsmanship, without a hint of the means employed. It sets false standards, and compares things that have not a common denomination. The sentence that seems to me to contain both the aesthetics and the morals of this question, I heard from the lips of Sir John Gilbert, a splendid authority. "I think", he said "an artist must do it all himself."'

11 cf Wendy Baron, *Sickert,* 1973, p 168; see also Aaron Scharf, *Art and Photography,* 1968, pp 33 and 192.

12 Emmons, op cit, p 213.

13 Ibid.

14 cf David Sylvester, 'Shapes in a Murky Pond', *New Statesman,* 4 June 1960, pp 960-1, 'Sickert had the boldness to leave unexplained and make no pretence of explaining those forms which did not explain themselves to the camera's eye. The portraits simply reflect back at us a sensation of the sitters sitting there, a sensation of their *there*-ness. This is life as one would see it if one had no feelings, no thought, no moral or aesthetic prejudices. And such is the grandeur of the conviction with which it is presented that life seen like this seems to be life as it is. Here is an empiricism as ruthless, as disenchanted, as raw, as absolute, as the empiricism of Hume'.

15 Virginia Woolf, *Walter Sickert: a Conversation,* 1934.

16 From 'Straws from Cumberland Market', see note 6 (p 246).

17 Lillian Browse, op cit, p 49.

18 As Forge has pointed out (Ibid), adding that Sickert's handling 'moves freely as though propelled by nothing but the hand and the eye', and quoting Sickert's observation that execution should be 'the singing of a song by heart, and not the painful performance in public of a meritorious feat of sight-reading'.

19 In Baron, op cit, p 172, where Lillian Browse is also quoted in a similar sense.

20 It is certainly true that the Echoes fitted perfectly into the growing cult of Victoriana of the 1930s.

21 cf Richard Morphet, 'Roger Fry: the Nature of his Painting', *The Burlington Magazine,* July 1980, pp 478-488.

22 *New Statesman,* 22 May 1926.

23 *The Spectator,* 31 August 1934.

24 Denys Sutton, *Walter Sickert,* 1976, pp 216-7.

25 See Note 16.

26 One younger English artist whose work shares these qualities is Bomberg.

27 Quoted in Baron, op cit, p 182.

28 Andrew Forge, 'Sickert's portrait of Hugh Walpole', *The Listener,* 7 October 1965, pp 531-2.

Sickert's late work

Helen Lessore

One of the most striking characteristics of Sickert's late pictures is the consistent treatment of the canvas as a surface, with an all-over equality of tension between the flat shapes into which it is divided, irrespective of what they represent. Some people say that this is due to the use of photographs, but this is only partly true, and to estimate the proportion of their influence it is necessary to glance rapidly at work of all periods. One then discovers this particular abstract quality appearing at intervals throughout his career.

Through all its stages his painting rested on the foundation of drawing, whether his own or someone else's or as he saw it implied in a photograph. He always believed in painting from drawings, as the old masters did, and, obviously in his early years, it was the only way of doing his music-hall pictures. He drew with extreme rapidity, keyed up to the highest possible pitch, often capturing the whole scene in a net of marks which, in the same process, created the composition – the design (in Italian the same word, *disegno*, does for both drawing and design). He once told me that when one was transferring a squared-up drawing to canvas, it was important to include all the accidents, because they were part of whatever it was that one had liked in the drawing. Though he never deliberately caused such accidents, there is an affinity here, as in other respects, with Francis Bacon. He did also eventually notice that the grid of squares on the canvas itself in some mysterious way contributed something to the painting, and in the last of all, *Temple Bar*, he actually re-painted the squaring-up lines after their original purpose had been served. Part of the magic lay in seeming to bring everything up to the surface.

The non-representational element (when unforced, unselfconscious) more profoundly and immediately than anything else distinguishes one painter's work from another's. Sickert's peculiar personal character, like the inimitable timbre and inflections of a very

individual voice, can be recognised in his work almost from the beginning, and yet, though it always recurs, it frequently vanishes – presumably because of his submitting himself to some strong influence or discipline. It is recognisable in the over-all weave of the design, and also in the idiosyncratic, rather angular flat shapes which constitute it, and these features recur from the 1880's onwards, especially in music-hall and theatre scenes, often in the drawings for them, but to a more pronounced degree in the etchings – because the lightness of the paper, or sometimes a grey tone, remaining between the lines of the shaded areas, in such etchings as for instance, *Noctes Ambrosianae*, binds the whole scene together into a flatter tapestry than the corresponding paintings, in which – not entirely of course, but relatively – the opaque mixtures of paint break the continuity of the surface. The newspaper photographs which inspired him in his old age and which consist of numbers of minute but visible dots and have a curiously patchy, blurred, almost stretched textile appearance, are actually reminiscent of the abstract tapestry of his own etchings of long ago, and it is probable that, both in themselves and because of this echo, they helped to clarify and bring at last to the surface of his consciousness that particular pictorial character which was a large part of his painterly identity.

The difficulty of achieving in paint the abstract qualities conspicuous in his etchings was overcome when a painting was left in an unfinished state, with a scatter of patches of bare canvas. In his final phase, a cool colour rapidly brushed over a warm underpainting (or vice versa) on a coarse canvas and in a restricted range allowed the undercoat to 'grin through', and this, together with the higher key and broad simplifications, acted like the luminosity of the paper as a containing plane.

This technique was most systematically worked out in

the Echoes, which were done from line-engravings after clear drawings by Victorian illustrators, and are more explicitly narrative and illustrational than anything else he ever did. Yet, paradoxically, being thus further removed from the content than he was in any of his other works, he was able to treat the Echoes the more freely as technical exercises. But while in some ways they seemed surprisingly modern, he was in fact looking back to the sixteenth-century Venetian painters, and believed that he had arrived at a method close to theirs, which should enable him to produce a similar web of glowing colour. He also told me that he sometimes left a partly painted canvas on a balcony, sloped to catch the rain, for several days, because this roughened and pitted the surface, giving it a granular look and increasing the effect of breadth he wanted. Being old then, he no longer had the physical energy necessary to make sustained drawings – certainly not out-of-doors – so it was a great convenience to take these ready-made compositions from a period to which he looked back with pleasant feelings, by draughtsmen he admired. He affected to feel romantic about them – *'J'ai la tête romanesque, Et j'adore le pittoresque/Giroflé, girofla!'*

And this was partly true, but it was also partly a theatrical, frivolous-seeming mask behind which he got to grips with what the Echoes are really about. For the drawing which states their nominal subject is often cursory and runs to caricature; the real drawing is in the interplay of shapes of colour. The *raison d'être* of such pictures as *Idyll* or *Summer Lightning* or *Dover* or the best of the interiors, such as *Woman's Sphere*, is the final mosaic of light-drenched colour – that is to say, something inseparable from the execution.

There is a Firbankian quality in Sickert's Echoes, in that the entire surface is an exquisite, shimmering decoration, while it is impossible to decide how much of the artist's feeling for the rather slight subject is affection, how much irony, how much pure aesthetic delight – or whether, indeed, a knife-edge balance between story and surface is not the true subject.

Several years before the Echoes, Sickert had been much struck by the Impressionists' way of turning tone into colour, especially in shadows, and under their influence and that of Gore and Gilman he did begin to lighten his palette. But during these Camden Town years, when he was probably spending more time on individual paintings 'from life' than at any other period, he often seems to have adopted almost a sculptor's attitude to 'making the form' – something like a moral feeling that the scene ought to be fully realised, in a three dimensional sense, with great solidity, recession, and tonal range – and this he did at the expense of the overall net of marks. There are both light and dark examples of these paintings. They are the most heavily realistic of any of his works, and I think the least personal are those in which Gilman's influence is strongest. Others – usually those which appear more quickly done – have a beauty of design and, even when very low-toned, a magical and quite personal harmony of colour. But others again are so dark all over that they really are like holes in the wall: one has to peer into their green and purple darkness to discover what they represent. Yet all these Camden Town pictures continue to exert a powerful spell, and many Sickert lovers like them best of all his production. They depict scenes which are drab, depressing, even sordid. In his choice of these scruffy subjects there was a moral attitude, learnt from Degas – the belief that an artist must be able to discover beauty in his own time and place. Sickert's was the murkier, more poverty-stricken world. But, like Degas, he remains emotionally aloof from his subjects. One cannot tell if he felt sympathy or compassion or cynicism. And I think the spell of these paintings – particularly of those so dark that they are hard to decipher – is that they are genre paintings pushed to an extreme: anything so extreme has a fascination. One feels that one has been brought to

the furthest limits of perception and expression, beyond which one would topple over into black, infinite nothingness.

The transition from those dark paintings to the last phase is astonishing. Possibly a longish illness in 1926, giving time for much thinking without working, may have contributed to the change. And among the late pictures there can be little doubt that the greatest are those done from photographs, whether taken according to his instructions, or existing ones which caught his imagination. And here, besides the other changes, there is also a change in his attitude to composition. I quote Emmons: 'Sickert has little to say on the subject of composition . . . He himself adopted the practice of the Impressionists of accepting nature's compositions as transmuted in the artist's drawing, leaving to the latter only (1) the choice of the subject, (2) the view point, (3) the cut, that is, the points at which each of the four sides of the pictures are (sic) to cut the scene, and (4) the colour'.

What is new and striking here is 'the cut', combined with the large scale. These late paintings are composed so that the figure − or perhaps two figures − occupy a large part of the rectangle, sometimes nearly filling it, like some of the most splendid compositions of the High Renaissance. And although − whether from principle or habit − he never departed from those limitations he had accepted in his youth, which for so many years seemed inevitably to produce genre painting with an accidental, even fragmentary look − the modest, intimate poetry of everyday − yet in extreme old age he succeeded in lifting his style to a completely different level, to a pitch of grandeur which only great artists have attained.

Sickert painted what he *saw* − without comment. *The Taming of the Shrew* recalls Titian's *Tarquin and Lucrece* in the marvellous energy and compactness of design, the brutality of the man, the backward movement of the woman; but it is an objective vision, compared with Titian's profoundly imaginative and sympathetic treatment. In fact, though all life interested him, it was art that deeply moved him − to admiration; and in the case of great actors and actresses, whose art gave a more intense (though controlled) expression of emotion than is usually met with in life, Sickert's appreciation of the rightness, the beauty, of their gestures is perceptible and warm. One may even compare his rendering of the grace of Peggy Ashcroft bending to place her chain about Orlando's neck − 'Wear this for me' − with the captivating beauty of gesture of Leonardo's Virgin, seated on the lap of St Anne, as she bends forward to place her hands about the Child. The *art* of Shakespeare, of Goldoni, of Verdi, moved him more than the raw material of that art.

Sickert once said to me, '*il faut viser à la longue* − and *never tell anyone* what it is you want'. And now it seems to me absolutely clear that what he wanted, from the beginning, was to paint great pictures, which could hang worthily − however different − beside the great pictures he loved best, in national collections.

Sickert at St Peter's

Denton Welch

Reprinted by kind permission of **David Higham** from *A Last Sheaf*, 1951, published by **John Lehmann**, pp 11-17

I had been in Broadstairs for months, trying to recover some sort of health after a serious road accident.

My doctor, knowing that I was an art student, tried to persuade Sickert to come and see me, but he wouldn't. I was told that he stormed off down the street, saying: 'I have no time for district visiting!'

That was while I was still in bed. When at last I got up, someone engineered an invitation to tea on Saturday afternoon. So he did not escape me after all.

Just as I was about to leave the nursing home for St. Peter's, Sister sailed into my room, closely followed by Gerald, an art school friend. He had evidently come all the way from London to see me.

I controlled my face as best I could and said: 'I'm going to tea with Sickert. What are you going to do? Can you wait here till I get back?'

He gave me one rapid glance and then said firmly: 'I'll come, too.'

I was horrified.

'But you haven't been asked!' I burst out.

'That doesn't matter. One more won't make any difference.

Feeling powerless in my convalescent state against his strength of will, I let him climb up beside me in the aged taxi which bore us swayingly to 'Hauteville.'

Sickert had not lived long in the house and it was still being altered. One entered through what at one time had been the 'cloakroom'! I remember with vividness the slight shock I received on being confronted with a glistening white 'WC' as soon as the door was opened.

Mrs Sickert stood beside it, welcoming us charmingly, with great quietness. She led us into what must have been the original hall. It was now a sort of dining-room, furnished with a strange mixture of interesting and common-place things. An early Georgian mirror with flat bevelling and worn gilt frame hung over the Art Nouveau grate. Seen thus together, each looked somehow startling and new.

We left our coats and passed on into the much loftier and larger drawing-room. The first thing I noticed was that the floor was quite bare, with that stained 'surround' which makes the white boards in the middle look so naked. By the sofa stood a stringy man who was about to go bald. The pale gold hair was still there, but one could tell how thin the crop would be next year. He looked at us with piercing eyes and fidgeted with his tea spoon. Mrs Sickert only had time to tell us that her husband was still resting but that he would be down soon, before this man engaged her again in earnest conversation. She could only show us attention by pouring out cups of tea. My cup was of that white china which is decorated with a gold trefoil in the centre of each piece. Gerald's was quite different. It was acid-blue, I think, with an unpleasant black handle and stripe; but I noticed that both our spoons were flimsy and old. I turned mine over and saw, amongst the other hall-marks, the little head of George III winking up at me.

I looked at the other things on the table, at the brown enamel teapot, the familiar red and blue Huntley and Palmer's tin, and at the strange loaf which seemed neither bread nor cake. In spite of myself, I felt that at least I was seeing Bohemian life.

I was glad that the man was keeping Mrs Sickert so busy, for it gave me time to stare at everything in the room. I saw that along most of the walls ran narrow panels, almost in monochrome. They looked like bas-reliefs flattened by a steam roller. They were most decorative. Mixed with these, but standing on easels or resting on the floor, were some of Sickert's own paintings. Gwen Ffrangcon-Davies dressed in Elizabethan farthingale and ruff, with harsh white light on her face, looked out from a picture mostly green and red.

Toylike, bustled ladies and Derby-hatted men, all in soft greys and pinks, skated on a country pond. Pinned to the canvas was the original *Punch* drawing from which the composition had been taken.

Near the fireplace stood the long, brown haggard picture of the miner with his swinging lamp, just come up from the pit, grasping his wife fiercely and kissing her mouth.

As I was looking at this last picture, Sickert appeared in the door. My first sight of him was rather overwhelming. Huge and bearded, he was dressed in rough clothes and from his toes to his thighs reached what I can only describe as sewer-boots.

He had seen me staring at the picture and now said directly to me: 'That picture gives you the right feeling, doesn't it? You'd kiss your wife like that if you'd just come up from the pit, wouldn't you?'

I was appalled by the dreadful heartiness of the question. I found myself blushing, and hated him for making me do so.

Sickert came right up to me and looked me all over.

'Well, you don't look very ill,' he said. 'I thought you'd be in a terrible mess. Didn't you fracture your spine or something?'

I nodded my head.

He made an amusing, whining baby's face.

'Look here, I'm very sorry I didn't come and see you, but I can't go round visiting.' He waved his hand round the room. 'You see, I have to keep painting all these pictures because I'm so poor.'

He took up a position with his back to the fireplace. Mrs Sickert got up and carried a cup of tea to her husband. The stringy man also rose and floated to the door. He was still talking to Mrs Sickert over his shoulder, and the last words I heard as he left the room were: '. . . couldn't pass water for six days!'

This sounded so surprising that for one moment I forgot Sickert. Then I remembered him with a jolt, for he had begun to dance on the hearth in his great sewer-boots. He lifted his cup and, waving it to and fro, burst into a German drinking song. There was an amazing theatrical and roguish look on his broad face.

I could not believe that he always drank his tea in this way, and I felt flattered, because he seemed to be doing it especially for us.

I don't know how long the dance or the song would have lasted if the front door bell had not rung. Sickert suddenly broke off and waited, while Mrs Sickert hurried out of the room.

She returned with a Mr Raven, whom I had met once before. After giving him a cup of tea, she left him standing on the hearth beside Sickert. He sipped his tea in silence for a few moments; then he began to feel in his breast pocket. At last he brought out a rather crumpled, shiny object, and I saw that it was a photograph.

'This is my mother,' he said, pushing it under Sickert's nose.

Sickert drew back perceptibly and gave a grunt which might have meant anything.

Mr Raven continued, unruffled. 'Interesting face, isn't it? If you'd like to do a painting of it, I'd be very pleased to lend you the photograph for as long as you liked.'

There was another grunt from Sickert.

When Mr Raven realised that this was the only answer he was going to get, he turned very red and hurriedly thrust the portrait of his mother back into his breast-pocket. He looked just as if he had been caught in the act of displaying an indecent postcard.

Gerald and I exchanged glances. I think we were both sorry for Mr Raven and yet glad that his efforts towards

cheap immortality for his mother had been frustrated.

Sickert, evidently prompted by Mr Raven's action, opened a drawer in a cabinet and also produced a photograph.

'Isn't she lovely?' he said, holding it out to me.

I took the yellowing little 'carte-de-visite' between my fingers and saw that it was of some young woman of the 'eighties. She had her back to the camera, so that her face was seen in profile resting on one shoulder. She appeared to me quite hideous with a costive, pouchy look about the eyes and mouth.

I wondered who she could be. Perhaps she was someone famous; or perhaps she was one of Sickert's past wives or mistresses.

I felt in a very difficult position. Thinking as I did, I hated to be sycophantic and say: 'Yes, she's beautiful.' So I compromised very clumsily by answering:

'The photograph is so tiny that I can't see very much of her; but I love the clothes of that period, don't you?'

Sickert snatched the photograph from me.

'Tiny! What do you mean by tiny?' he roared.

He held the picture up and pointed to it, as if he were demonstrating something on a blackboard; then he shouted out in ringing tones for the whole room to hear.

'Do you realise that I could paint a picture as big as this' (he stretched out his arm like an angler in a comic paper) 'from this "tiny" photograph as you call it?'

Horribly embarrassed and overcome by this outburst, I smiled weakly and cast my eyes down so that they rested on his enormous boots.

I was not thinking of his boots. I was thinking of nothing but the redness of my face. But Sickert evidently thought that I was curious, for the next moment he had opened another attack with:

'Ah, I see that you're staring at my boots! Do you know why I wear them? Well, I'll tell you. Lord Beaverbrook asked me to a party, and I was late, so I jumped into a taxi and said: "Drive as fast as you can!" Of course, we had an accident and I was thrown onto my knees and my legs were badly knocked about; so now I wear these as a protection.'

In a dazed way, I wondered if he meant that he wore the boots to protect the still bruised legs, or if he meant that he intended to wear them as a permanent safeguard, in case he should ever again have an accident as he hurried to a party of Lord Beaverbrook's. I thought of the sensation they would create amongst the patent leather shoes.

By this time I was so exhausted that I was pleased when Sickert turned his attention to Gerald. He started to talk about politicians, and I thought it was clever of him to guess that Gerald had an enormous appetite for tit-bits about the famous.

As I sank down on the sofa beside Mrs Sickert, I heard them begin on Anthony Eden. Sickert was describing his good looks. He must have sensed that I was still listening, for he suddenly turned his face on me, and his eyes were twinkling with fun and malice.

'Ugly ones like us haven't a chance when there's someone like Eden about, have we?' he called out across the room.

I was so surprised at being lumped together with Sickert in ugliness, as opposed to the handsomeness of Anthony Eden (who had never struck me as anything but middle-aged) that I took him quite seriously and could answer nothing.

I hurriedly tried to compensate myself for the humiliation by telling myself that, although it might not be saying very much, I was undoubtedly by far and away the best-looking person in the room, and this in spite of my long illness.

Mrs Sickert saw that I was ruffled and very kindly started to talk about my career. She asked me if I intended to go back to an art school when I was well enough. We discussed the various objects in the room. She told me that the two glittering monstrances had come from a Russian church. We went up to them and I took one of the sparkling things in my hands. The blue and white paste lustres were backed with tinsel. They were fascinatingly gaudy and I coveted them.

We sat talking together on the sofa for a little longer. Through our words I caught snatches of what Sickert was saying. Gerald evidently had got him on to Degas and anecdotes were streaming out. Gerald was drinking them up thirstily, while Mr Raven hovered rather uncomfortably at the edge of the conversation.

At last he decided to go. Coming forward, he coughed slightly and held out his hand to Mrs Sickert. Then, as he passed Sickert on his way to the door, he felt in his pocket and with almost incredible courage brought out the crumpled little photograph again.

Putting it down on the table, he said simply: 'I'll leave this just in case . . .'

His voice tailed off as he saw the completely blank look on Sickert's face. I knew exactly what was coming and waited for it.

Sickert gave the same enigmatic grunt. It was somehow quite baffling and insulting.

Mr Raven crept unhappily to the door and Mrs Sickert followed swiftly to put salve on his wounds.

Immediately Raven was out of the room Sickert became boisterous. He started to dance again, thumping his great boots on the floor. Gerald and I caught some of his gaiety. We did not mention Raven, but I knew that we were all celebrating his defeat. It was pleasant to feel that Sickert treated us as fellow artists. I wondered how many people each year asked him to paint pictures for love.

As Mrs Sickert did not return, we went into the hall, where Sickert dragged on our coats as if he were dressing sacks of turnips. Then dancing and singing in front of us, he led the way through the 'cloakroom' to the front door. I half expected some remark about the shining flush-closet, but none came.

It was dark outside. We walked over the greasy cobbles. Sickert was leading us. He threw open the creaking stable-yard door and stood there with his hand on the latch. He looked gigantic.

We passed through and started to walk down the road.

'Goodbye, goodbye!' he shouted after us in great good humour. 'Come again when you can't stop quite so long!'

And at these words a strange pang went through me, for it was what my father had always said as he closed the book, when I had finished my bread and butter and milk, and it was time for me to go to bed.

Chronology

Wendy Baron

Biography of Walter Richard Sickert (born 1860) from his third marriage in 1926 until his death

Note: Numbers in brackets refer to the present catalogue

1926

4 June. Married the painter Thérèse Lessore (formerly Mrs Bernard Adeney), a friend for many years (see note to No 36). After their marriage they visited Margate, Newbury, and then stayed in Brighton where Sickert took a studio in Kemp Town. Breakdown in health this year (probably a slight stroke).

1927

On their return to London Sickert and his wife settled in a house at 15 Quadrant Road, Islington. Sickert's eccentricity began to be more marked and expressed itself in the instructions he gave his builders to remove the conventional lavatory pans and replace them with the French-type hole in the floor (in order, he said, to see his visitors' faces as they emerged and when necessary to rush to the aid of the distressed lady guests).

May. Exhibition of 28 drawings at the Savile Gallery. Finally adopted his second name Richard for all purposes, having compromised over the past two years with Walter R Sickert. Exhibited three early works at the RA his submission of the unfinished portrait of *Rear Admiral Lumsden* (No 10), begun in Brighton early in the year, having been rejected. Also exhibited with the London Group (June).

Autumn. Opened the last of his private *ateliers*, at Highbury Place, Islington. Lord Methuen, Morland Lewis, his future biographer Robert Emmons, and Mark Oliver who went into partnership with R E A Wilson of the Savile Gallery, were among the handful of pupils who attended. The school was for men only and no models were used. By this time Sickert painted almost exclusively from photographs. His pupils were taught to square up their designs, transfer them to canvas and lay them in with a *camaieu* preparation composed of four tones of two colours. Began to paint the Echoes, taking his designs from Victorian black-and-white illustrations, although he took the design of his first Echo, *Suisque Praesidium* (No 59), from the lid of a pomade pot. Elected President of the RBA at the end of the year, and added a flamboyant PRBA to his signature.

1928

February. Exhibition of 38 paintings and 7 drawings (retrospective and recent) at the Savile Gallery including his earliest Echoes (Nos 59-60) and his portrait of the *Rt Hon Winston Churchill* (No 9), then Chancellor of the Exchequer, to whom he had been giving painting lessons. Catalogue preface written by Hugh Walpole.

April. London Group Retrospective exhibition included a group of Sickert works.

May. Exhibited *Rear Admiral Lumsden* (No 10) a life-size full-length portrait, at the RA where it excited much comment.

November. A portrait of Cicely Hey sold at Christie's from Sir Michael Sadler's collection for 660 guineas. The Leicester Galleries in 1928 and 1929 published a large series of the etchings and engravings made by Sickert throughout the 1920s (after which this branch of his activity ceased).

1929

Habit of besieging the daily press with letters on a variety of topics began and continued until 1932, *The Times* being the favourite recipient in 1929.

February. Thirty-two paintings (a whole room) by Sickert in an exhibition of Modern English Art in Brussels. Exhibited with the London Group in January (the portrait of *Hugh Walpole*, No 12) and November. His picture of *Sir Nigel Playfair* in the part of 'Tony Lumpkin' (No 39) was the cynosure of the Royal Academy. Sickert donated the money he had been given for this commissioned picture (paid by subscription as a presentation to Sir Nigel) to the Sadler's Wells rebuilding fund. Sickert himself went frequently to Sadler's Wells at this period.

June. Large retrospective exhibition at the Leicester

Galleries who joined the Savile Gallery as one of Sickert's main dealers. Painting *The Raising of Lazarus* at Highbury Place where he used the wall (papered) for his preliminary full-scale sketch.

December. Resigned from the RBA

1930

March. Exhibition of paintings and drawings including his self-portraits, *Lazarus breaks his Fast* (No 1) and *The Servant of Abraham* (No 2) at the Savile Gallery.

May. Exhibited a portrait of his eye specialist *Dr. Cobbledick* (No 14) at the RA.

October. Exhibited *The Tichborne Claimant* (No 64) with the London Group.

November. Exhibition at the Galerie Cardo in Paris.

1931

Moved from Quadrant Road to 14 Barnsbury Park, Islington (where he had many of the windows bricked up). Gave up several studios including the ones in Kemp Town (Brighton) and Noel Street.

May. Exhibited at the RA and had an exhibition of 'English Echoes' at the Leicester Galleries.

October. Showed *A Conversation Piece at Aintree* (No 15) with the London Group. When the Beaux Arts Gallery offered this picture of King George V with his racing manager to the Glasgow Art Gallery the City Council turned it down as not majestic enough. It is now owned by HM Queen Elizabeth The Queen Mother.

1932

During the year became increasingly interested in painting scenes from contemporary productions of classic plays. He painted his subjects from photographs and was thus able to continue doing them after his removal to Thanet. Peggy Ashcroft, Gwen Ffrangcon-Davies and Edith Evans were among the actresses whom he portrayed, in many roles, most frequently.

April. Exhibition at the Beaux Arts Gallery (run by Sickert's brother-in-law) included many Echoes. The Beaux Arts and the Leicester Galleries between them now became Sickert's main dealers.

May. Received an Hon LLD from Manchester University. Exhibited *The Raising of Lazarus* at the RA (and sold it for the benefit of Sadler's Wells at Christie's in December where it was bought by the Beaux Arts Gallery).

October. Exhibited with the London Group

The Louvre bought *Hamlet, an Echo* after John Gilbert, from the Leicester Galleries.

1933

Exhibitions at REA Wilson's Gallery (the Savile Gallery was now defunct) and at the Beaux Arts Gallery. Also exhibited at the RA (No 17) and in November with the London Group.

November. Major loan exhibition at Agnew's (who had since 1906 included works by Sickert in several of their mixed shows of British Art and had sent a group of his paintings to New York in December 1929 in a show of Contemporary British Artists).

1934

Virginia Woolf's pamphlet *Walter Sickert: a Conversation*, an imaginary discussion of his work inspired by the Agnew loan exhibition, published.

Became a full Academician and at the RA exhibited a portrait of Sir James Dunn, one of a group of life-size portraits of himself and his friends (see Nos 20-22) commissioned by Sir James to help Sickert out of his financial difficulties. Subscription fund raised among other friends and admirers to enable Sickert to work free from financial anxiety.

Summer. Margate where Sickert began to lecture at the Thanet School of Art. He and his wife decided to settle in the neighbourhood.

November. 18 recent paintings exhibited at the Leicester Galleries.

Also exhibited with the London Group.

End of the year. Moved to Hauteville, St. Peter's-in-Thanet.

1935

May. Exhibited at the RA, one of his submissions being the full-length, life-size, vividly coloured portrait, com-

missioned by Sir James Dunn, of *Viscount Castlerosse* (No 21). His portrait of *Lord Beaverbrook* (No 22), another of the Dunn commissions, was rejected by the selection committee.

Resigned from the RA (as a protest against the President's refusal to sign an appeal for the preservation of Epstein's sculptures on the British Medical Association's building in the Strand).

July. 12 new paintings shown at the Beaux Arts Gallery.

October. Exhibited two paintings at the NEAC (non-member), probably because it was the 50th Anniversary of its constitution.

November. Exhibited the sketch for *The Raising of Lazarus* with the London Group.

1936

January. Exhibition of early paintings at the Redfern Gallery. April. Exhibition of recent paintings at the Leicester Galleries. Resigned from the London Group.

1937

January. Exhibition of 'Sickert and the living French painters' at the Adams Gallery.

April. Exhibition of paintings at the Beaux Arts Gallery. December. Exhibition of 68 early paintings at the Redfern Gallery.

1938

January-February. Retrospective loan exhibition of 30 paintings at the Arts Club, Chicago and then at the Carnegie Institute, Pittsburgh. Sickert had sent pictures to the Pittsburgh Annual International Exhibitions from 1923-7 and from 1931-9. From time to time during this period he also sent his work to other international exhibitions, for example to the Venice Biennale. In 1938 in Paris (Musée du Louvre), in an exhibition of English painting of the 18th and 19th Centuries, he was represented by 9 paintings.

March. 21 recent paintings shown at the Leicester Galleries. Received an honorary D Litt this year from the University of Reading. End of the year. Moved to St George's Hill House, Bathampton.

1939

Lectured at the Bath School of Art until war broke out.

May. Exhibition of early paintings by Sickert (and William Nicholson) at the Beaux Arts Gallery.

June. Sickert one of the 'Trois Peintres Anglais' exhibited at the Galerie Bing in Paris where he was represented by 14 paintings. A group of his pictures was also sent to the World's Fair, New York this year.

1940

February. 25 paintings exhibited at the Redfern Gallery.

April. 15 recent paintings exhibited at the Leicester Galleries. (Recent paintings now meant, as it had done for some years, mostly Echoes and landscapes – painted from photographs – of Sickert's immediate environment).

W H Stephenson's book *Sickert: The Man and his Art. Random Reminiscences,* published this year. It was an account of the author's relationship with Sickert from 1923-5.

1941

Group of pictures exhibited at the First American-British Arts Center show in the United States.

Publication of Robert Emmon's *The Life and Opinions of Walter Richard Sickert* which to this day remains the major comprehensive portrait of Sickert as man, artist, writer and teacher.

Autumn. Major retrospective exhibition of 132 paintings and drawings, organized by Lillian Browse, held at the National Gallery. Sickert had been approached in January 1938 concerning a projected exhibition to open at the Tate Gallery in June 1939. This exhibition was first postponed until the Autumn and then abandoned altogether in favour of the National Gallery exhibition. The Tate kept pictures already collected in 1939 and these were included in the National Gallery show (it seems erroneously catalogued as having been exhibited at the Tate in 1939).

1942

22 January. Died at Bathampton. His wife, Thérèse Lessore, survived him to die in 1945.

Bibliographical note

The major monograph on Sickert is the following:

Baron, Wendy, *Sickert*, London, Phaidon, 1973

As this volume includes an extensive bibliography we have not included one here, but list instead a few titles that are not mentioned in the above and are relevant to late Sickert:

Auerbach, Frank, 'Homage to Sickert', *The Listener,* 14 June 1973, p 807

Ayrton, Michael, 'An Obscure Person', *New Statesman,* 28 May 1960

Baron, Wendy, 'The Perversity of Walter Sickert', *Arts* (USA), September 1980, pp 125-129

Bell, Clive, 'Sickert at the National Gallery', *New Statesman and Nation,* 6 September 1941

Brook, Helen, 'Richard Sickert: "Originals" and "Echoes"', *Studio,* May 1932, pp 266-272

Earp, T W, 'Richard Sickert: English Echoes', *Apollo,* Vol 13, June 1931, pp 344-47

Forge, Andrew, 'Sickert's portrait of Hugh Walpole', *The Listener,* 7 October 1965, pp 531-2

Kozloff, Max, 'Sickert's Unsentimental Journey', *Art News* (USA) April 1967, pp 51-3 and 71-2

Morphet, Richard, 'The Modernity of Late Sickert', *Studio International,* Vol 190, July-August 1975, pp 35-8

Sutton, Denys, *Walter Sickert*, Michael Joseph, 1976

Sylvester, David, 'Shapes in a Murky Pond', *New Statesman,* 4 June 1960

Welch, Denton, *A Last Sheaf,* John Lehmann, 1951, pp 11-17

'Sickert at the Leicester Galleries', *Apollo,* March 1938, pp 156-159

Colour plates

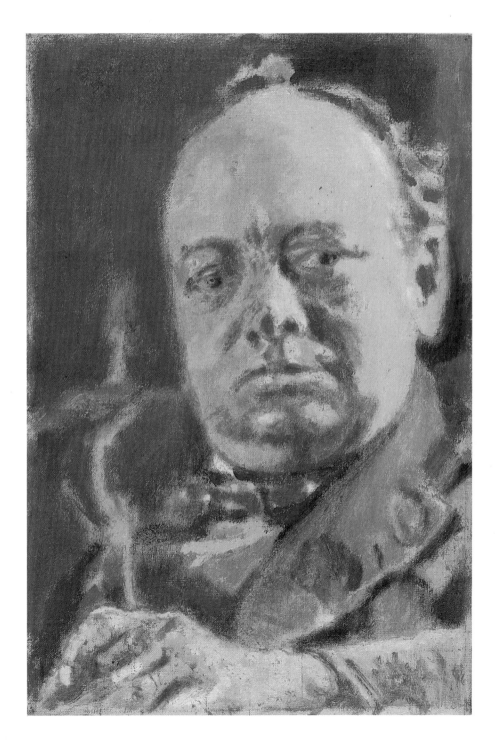

9
The Rt Hon Winston Churchill *c*1927

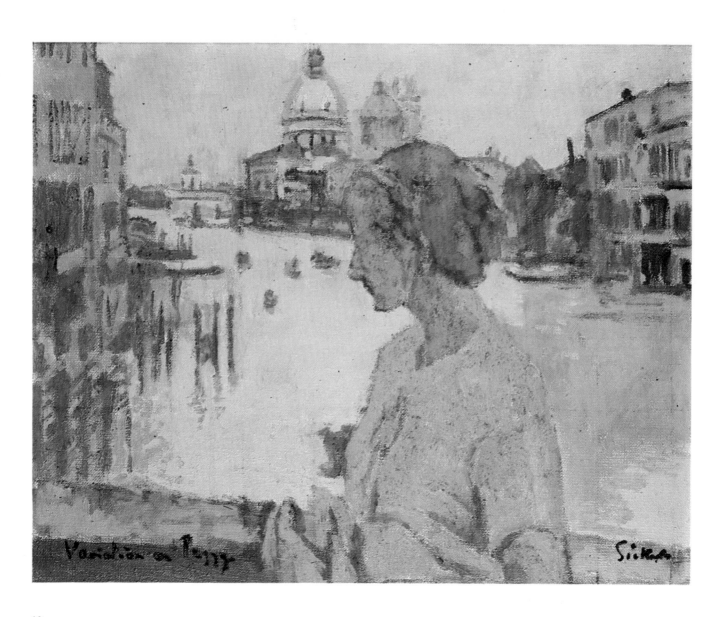

19
Variation on Peggy c1934-5

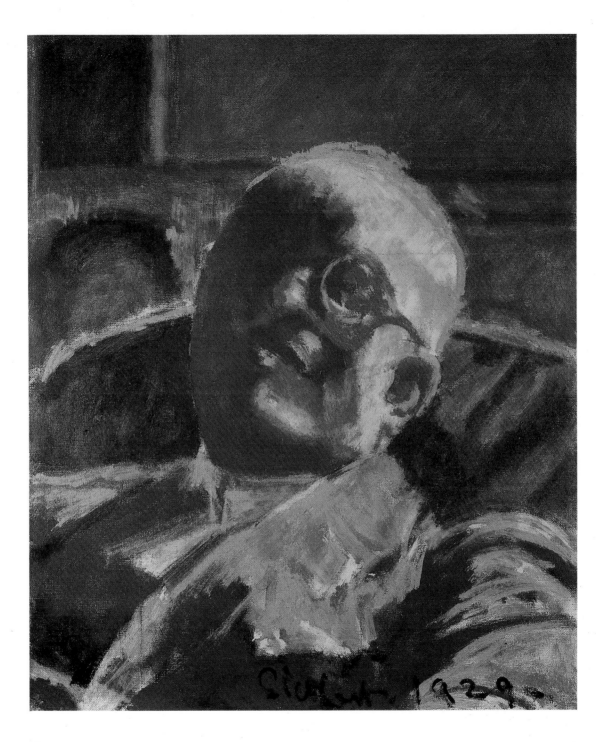

13
Hugh Walpole 1929

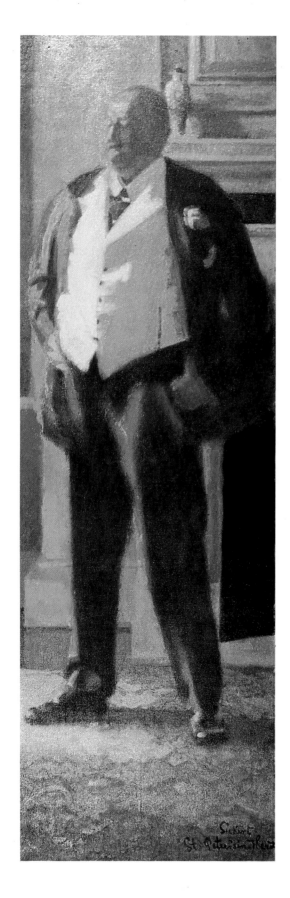

21
Viscount Castlerosse 1935

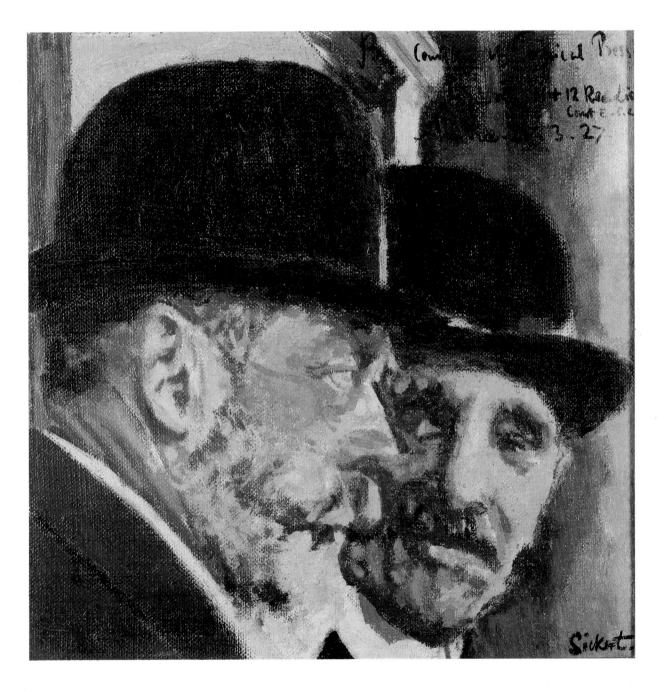

15
King George V and his Racing Manager c1927-30

To our dear fils

25
Claude Phillip Martin 1935

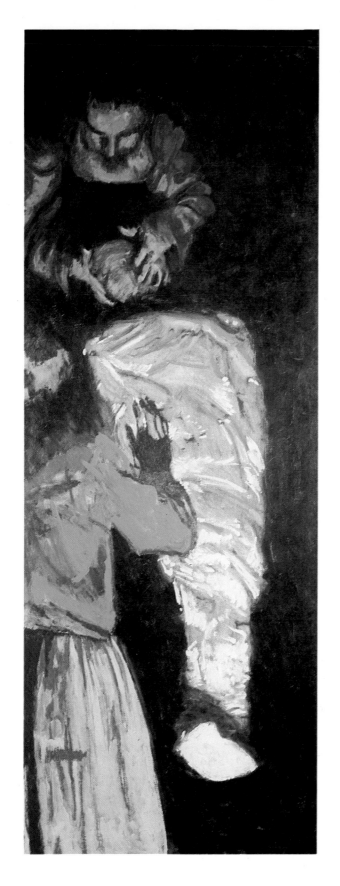

Not exhibited
The Raising of Lazarus c1929-32, 96 × 36 (243.9 × 91.5)

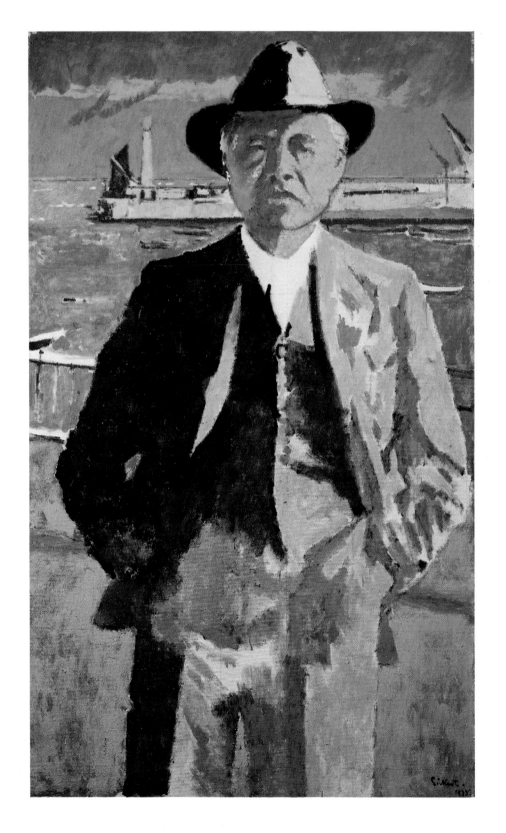

22
Lord Beaverbrook 1935

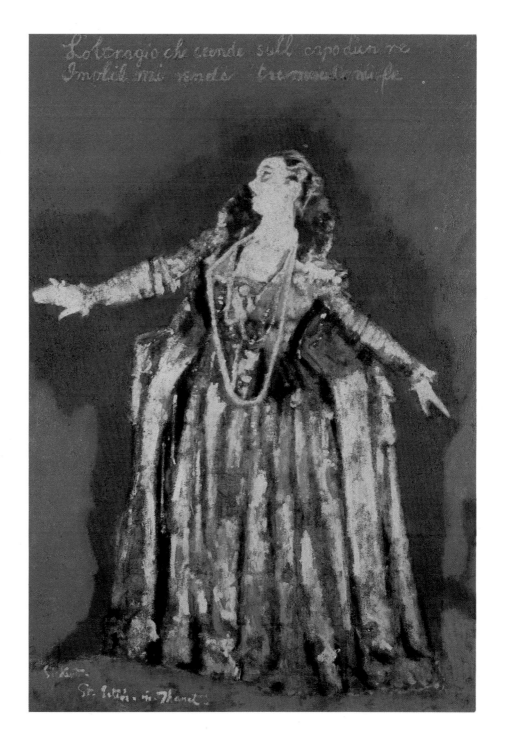

50
Gwen Again *c*1935-6

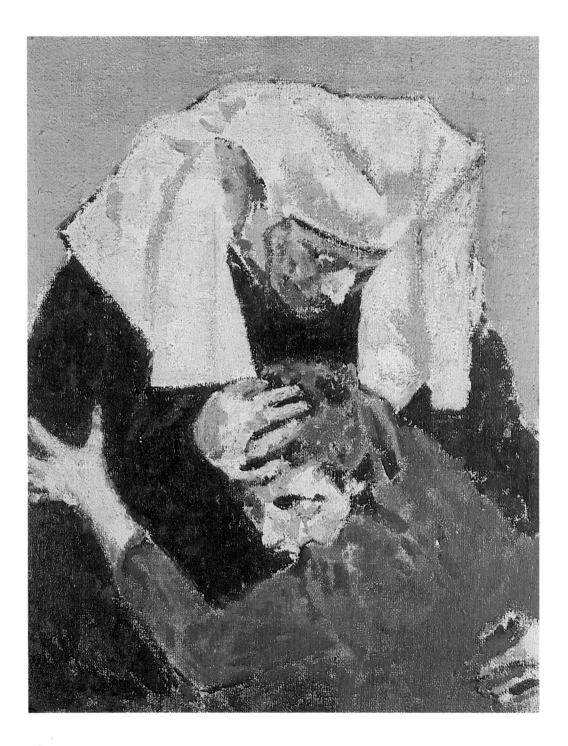

49
Juliet and her Nurse 1935-6

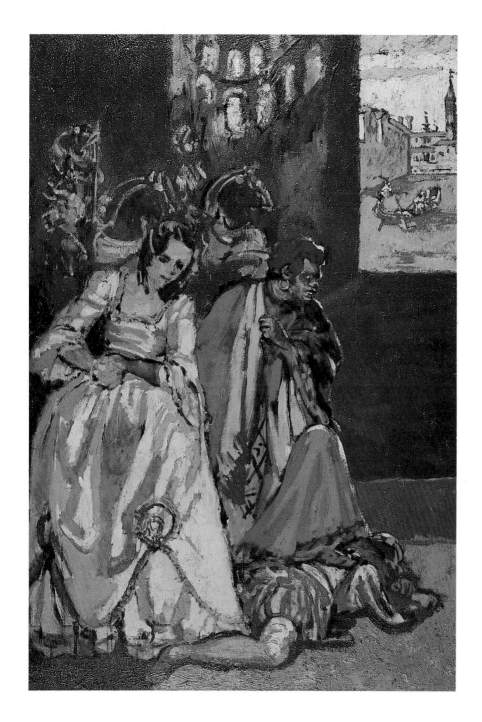

44
Variation on 'Othello' *c*1932-4

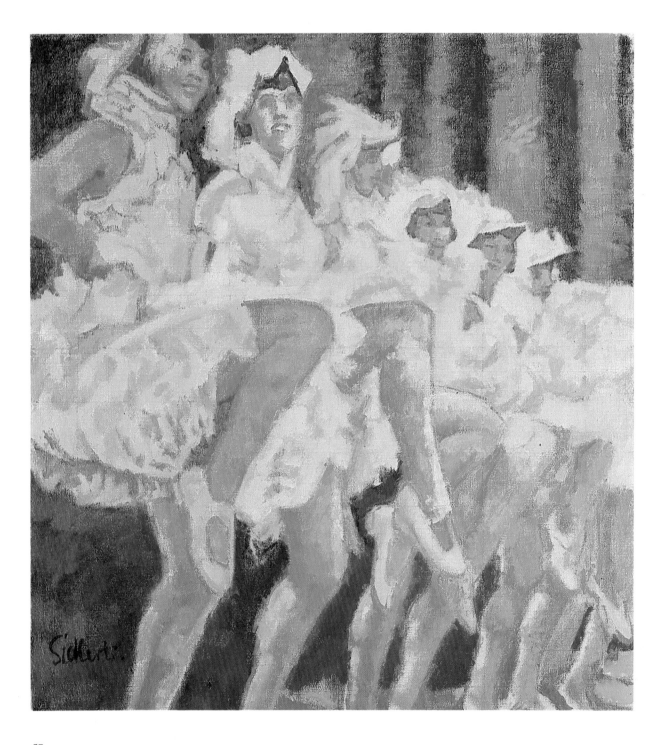

57
High Steppers *c*1938-9

74
Idyll c1931-2

89
Sirens Aboard c1937

46

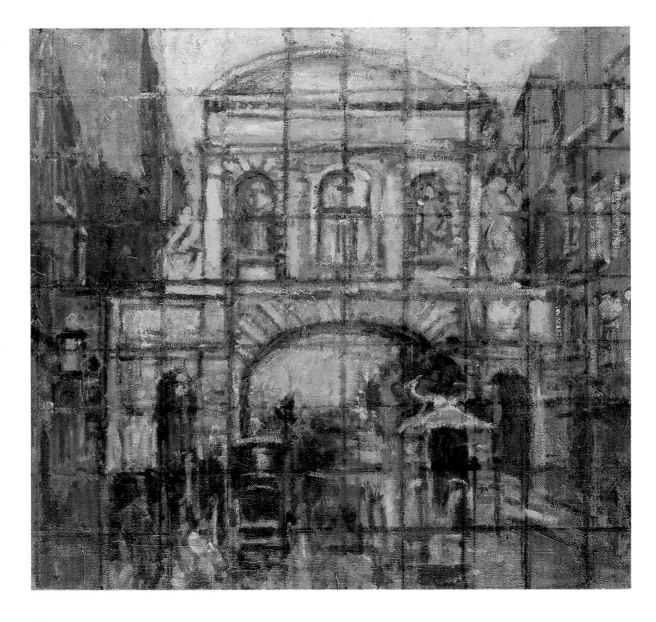

94
Temple Bar *c*1941

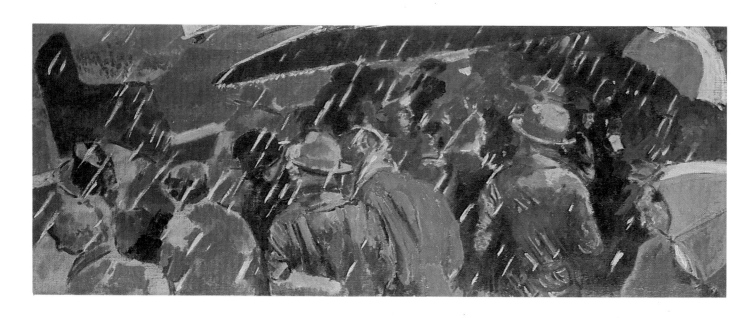

97
Miss Earhart's Arrival 1932

100
Hubby *c*1936-8

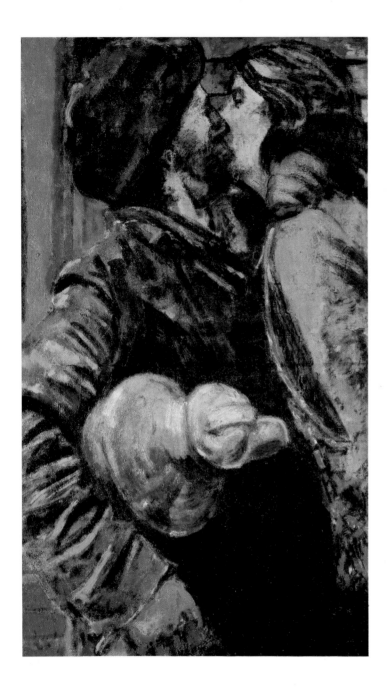

98
The Miner 1935-6

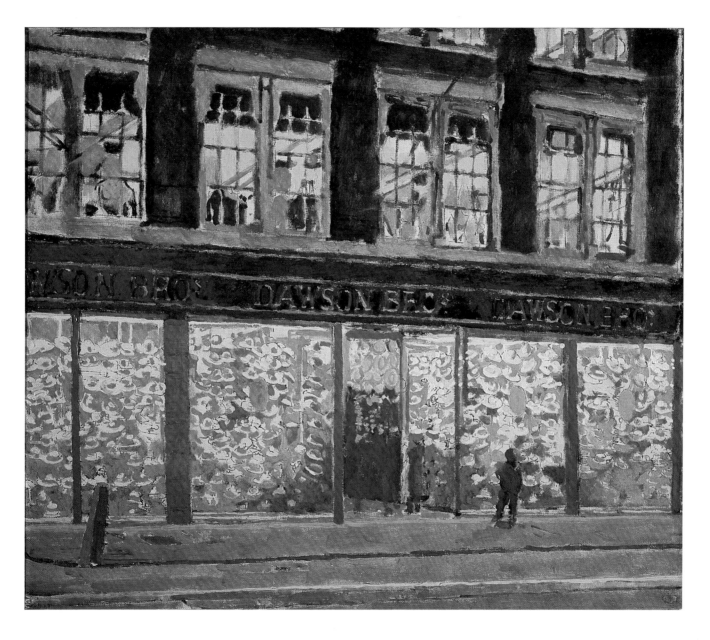

103
Easter *c*1928

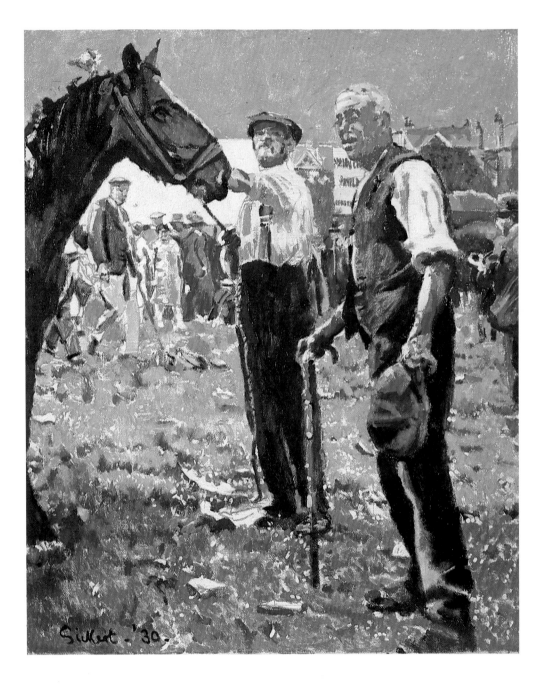

104
Barnet Fair 1930

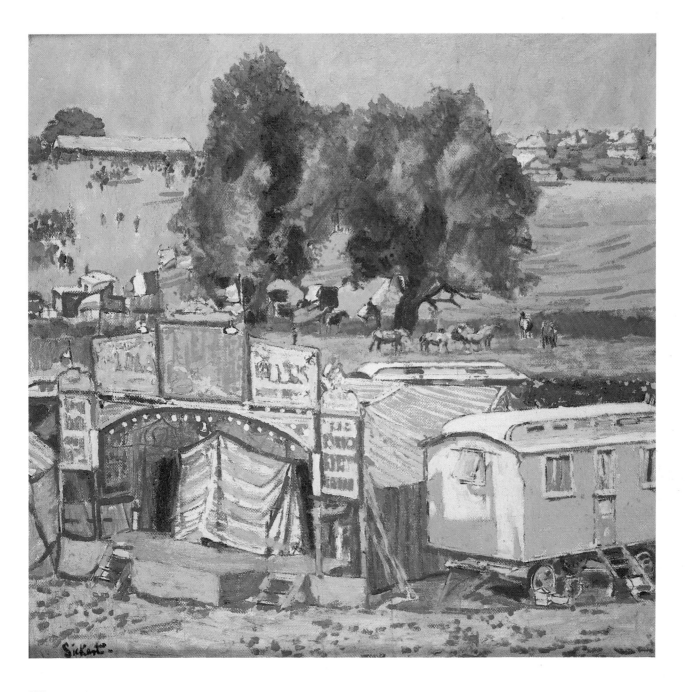

105
Barnet Fair *c*1930

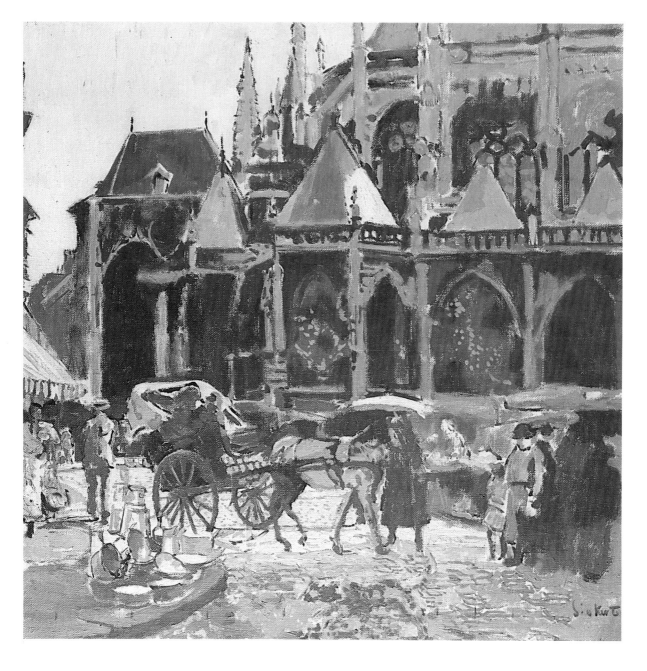

107
La Rue du Mortier d'Or c1932-4

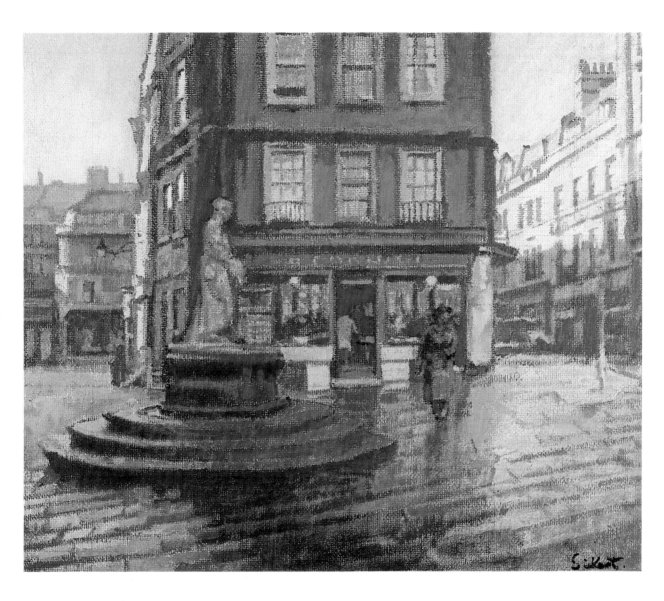

113
Abbey Yard, Bath 1939-40

121
Bathampton c1941

Monochrome plates

Self portraits

3
The Front at Hove 1930

4
Self portrait in Grisaille c1935

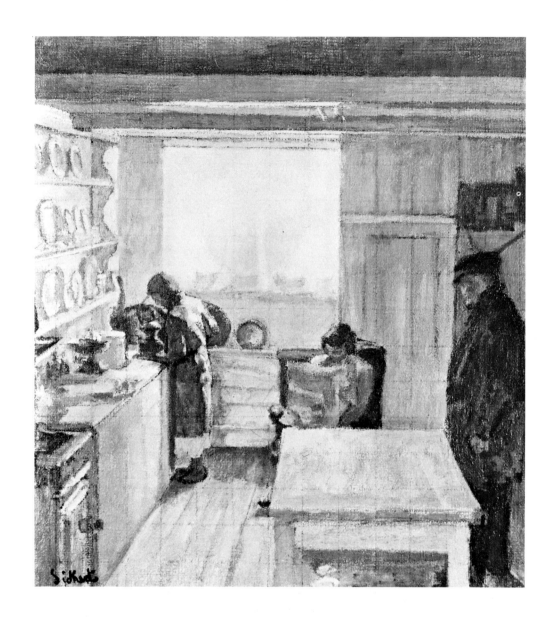

5
A Domestic Bully *c*1935-8

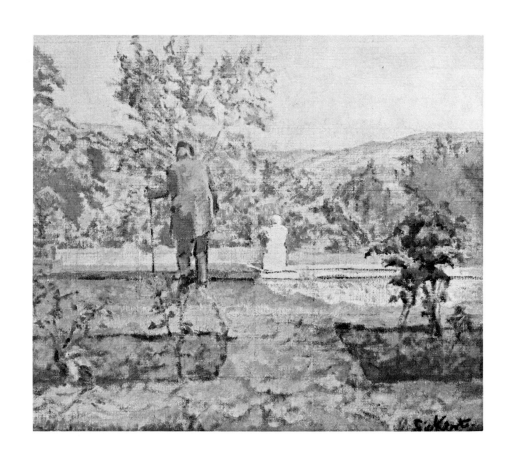

7
The Invalid c1939-40

8
Reading in the Cabin 1940

Portraits

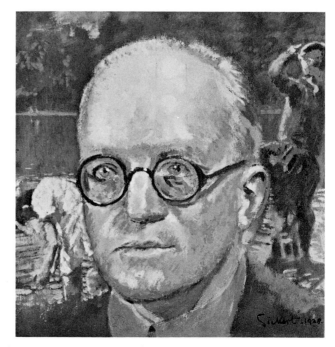

12
Hugh Walpole 1928

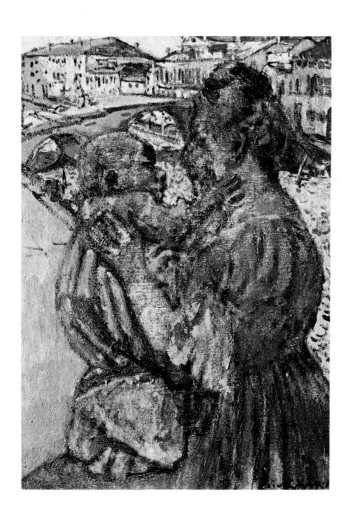

11
Viscere Mie 1927-8

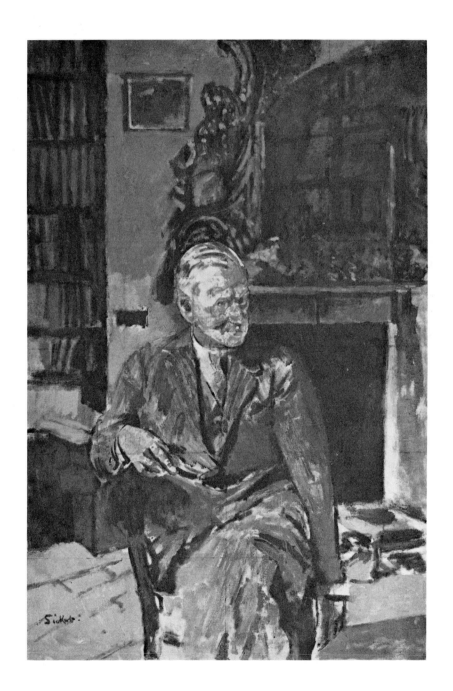

20
Sir James Dunn, Bt 1934

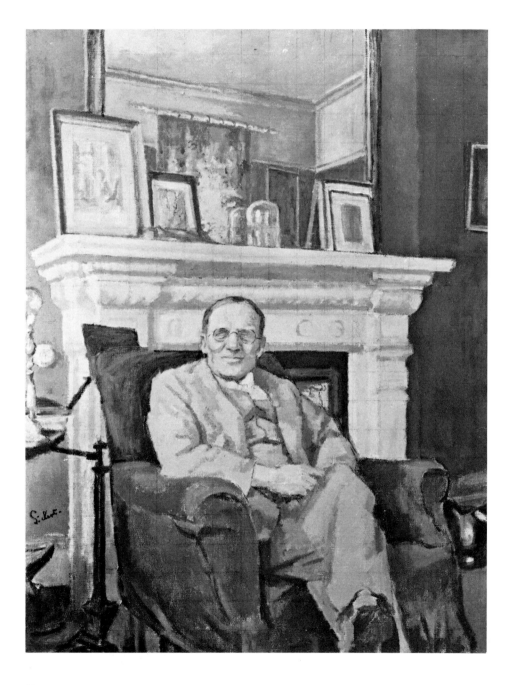

23
Sir Alec Martin, KBE 1935

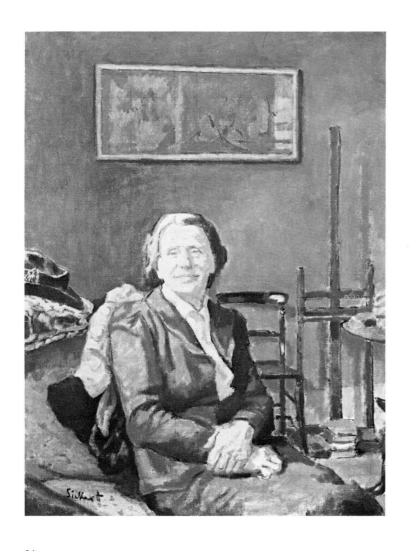

24
Lady Martin 1935

Not exhibited
King George V and Queen Mary, 1935,
25 × 29¾ (63.5 × 75.5) Private Collection.

26
Bude: Girl with Two Dogs c1935

27
The Row c1935

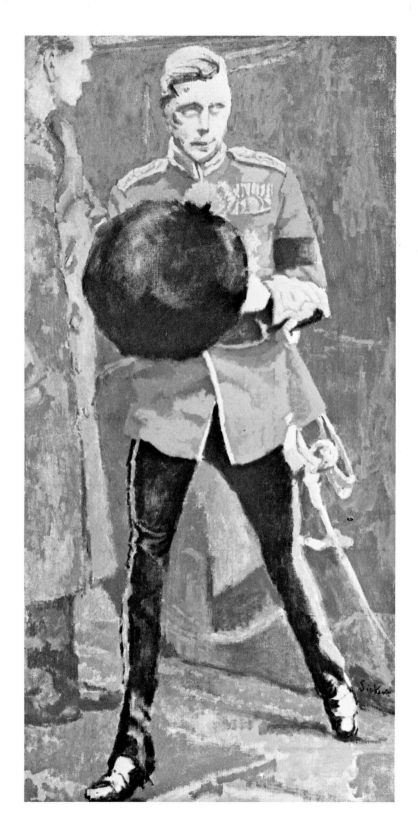

28
Conchita Supervia c1935

29
HM King Edward VIII 1936

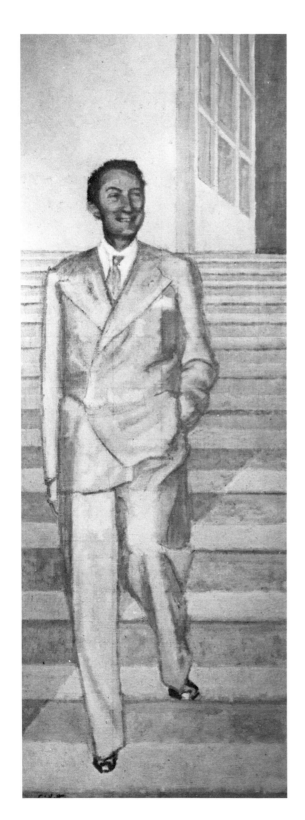

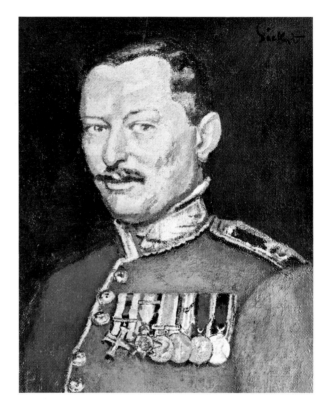

34
AHC Swinton 1938

33
Alexander Gavin Henderson, 2nd Lord Faringdon

Theatrical subjects

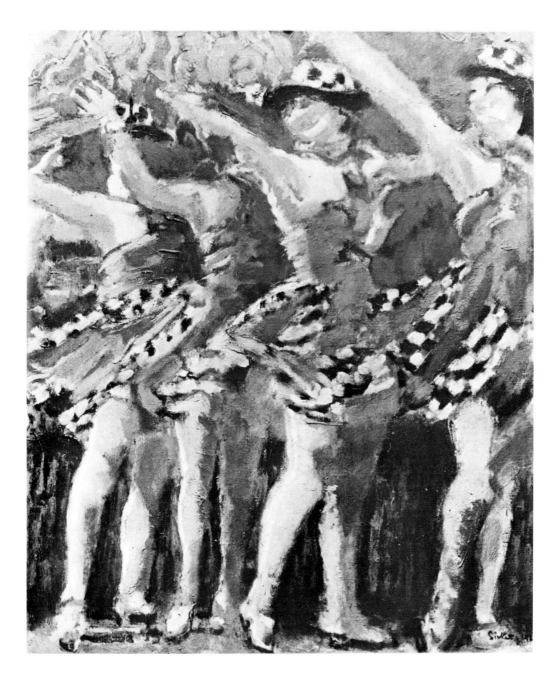

38
The Plaza Tiller Girls 1928

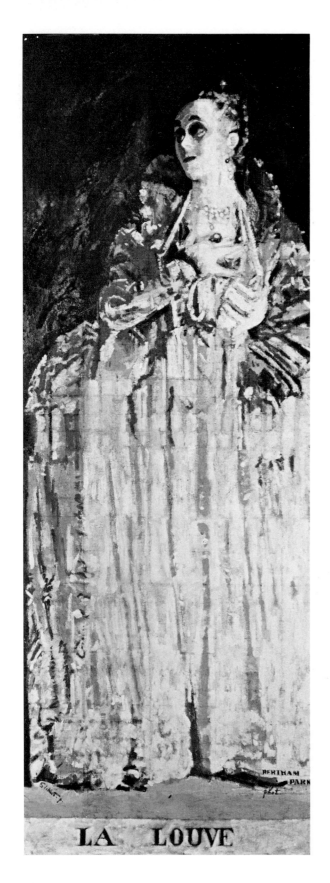

LA LOUVE

41
Miss Gwen Ffrangcon-Davies as Isabella of France: La Louve 1932

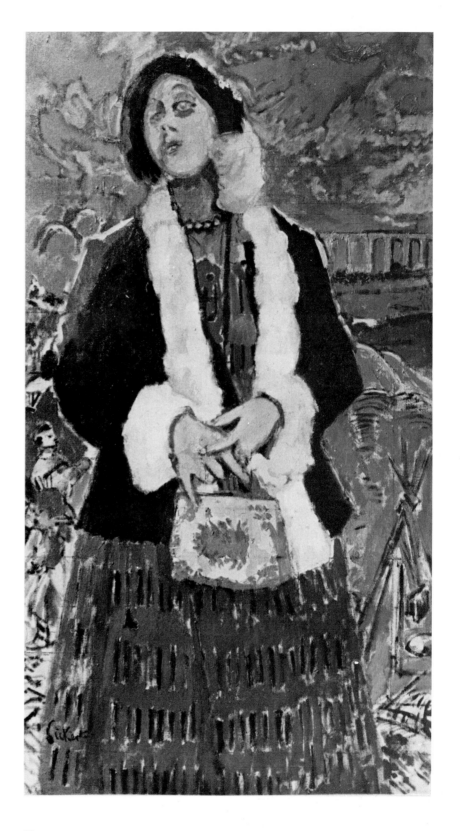

42
Gwen Ffrangcon-Davies in *The Lady with a Lamp* *c*1932-4

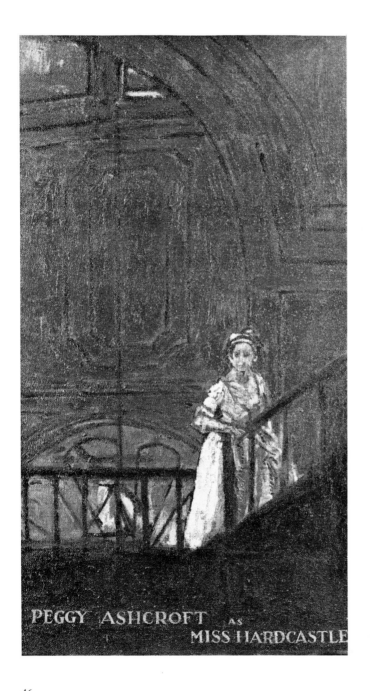

51
Peggy Ashcroft and Paul Robeson in *Othello* c1935-6

46
Peggy Ashcroft as Miss Hardcastle in *She Stoops to Conquer* 1933-4

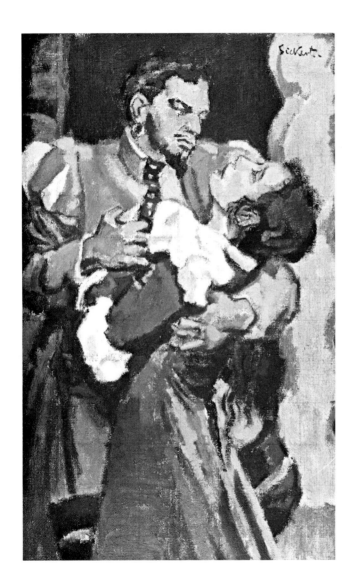

52
The Taming of the Shrew *c*1937

58
Mr Maxton as Hamlet

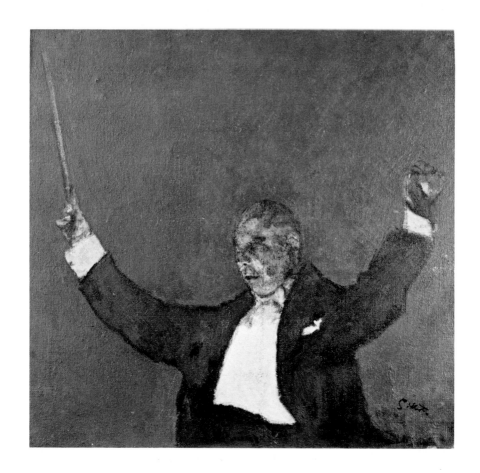

56
Sir Thomas Beecham Conducting 1938

54
Jack and Jill 1936

Echoes

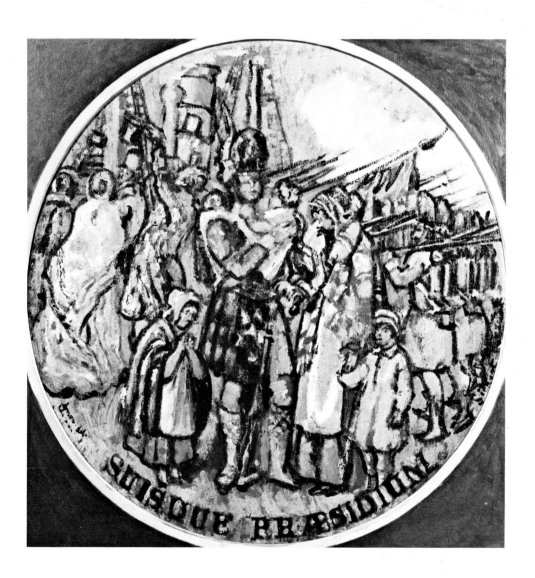

59
Suisque Praesidium *c*1927

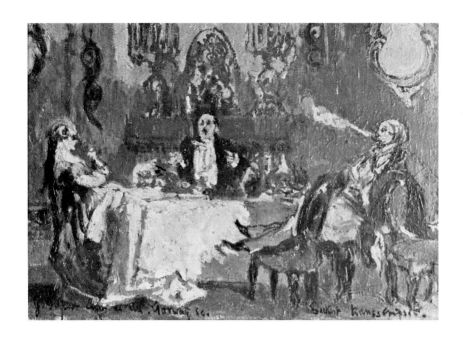

60
La Traviata c1927-8

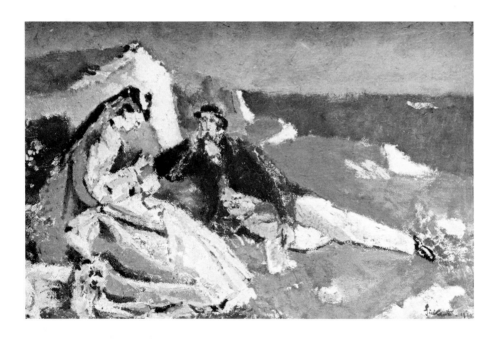

63
The Beautiful Mrs Swears 1930

74

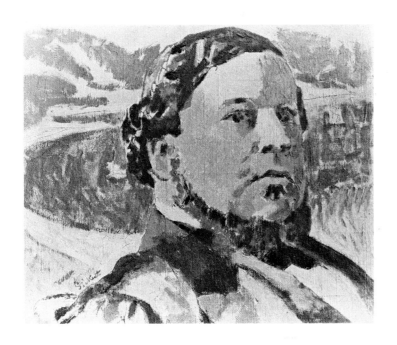

64
The Tichborne Claimant *c*1930

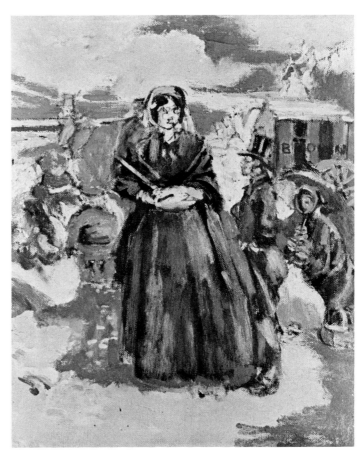

62
O it's Nice to be beside the Seaside *c*1929-30

67
The Bart and the Bums c1930

68
The Private View at the RA c1930

69
The Two Lags c1930-1

70
On Her Majesty's Service c1930-1

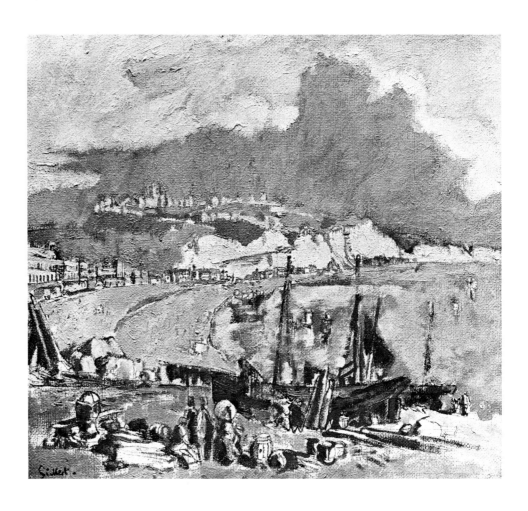

72
Dover *c*1931-2

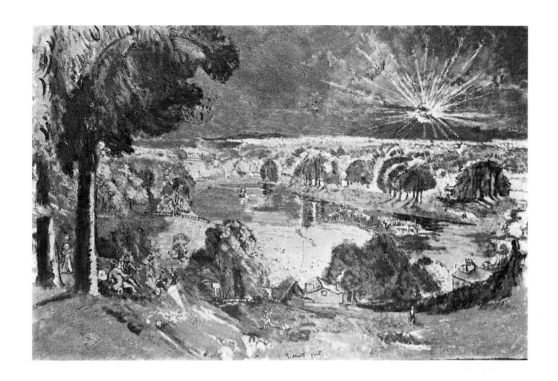

81
Grover's Island from Richmond Hill 1932

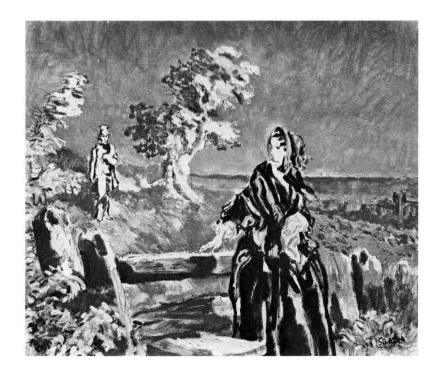

73
Summer Lightning *c*1931-2

83
Juan and Haidée *c*1930-34

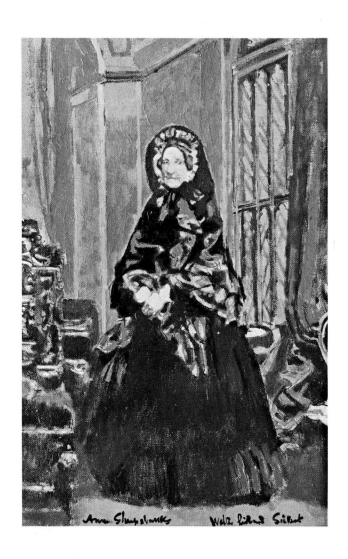

75
Anne Sheepshanks *c*1931-2

80

84
The Bush *c*1933-4

85
The Boudoir *c*1933-4

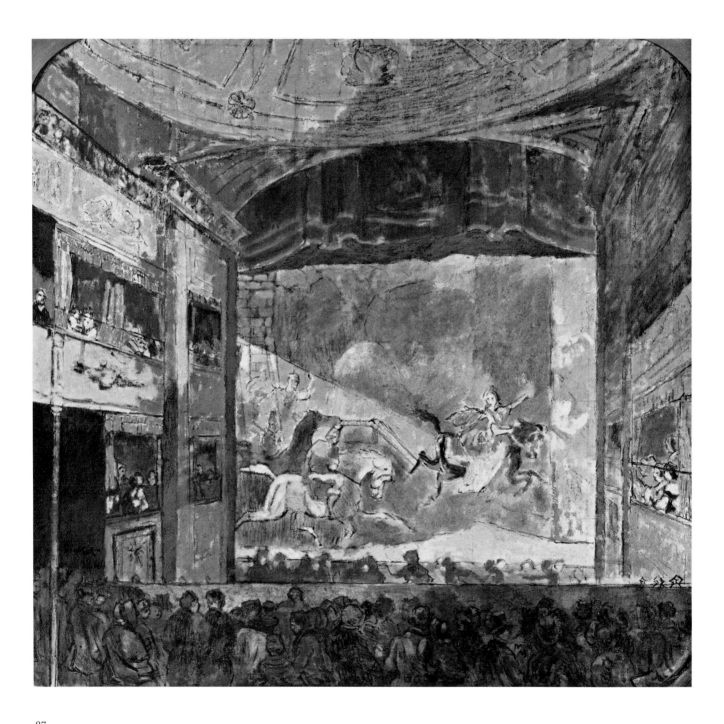

87
The Standard Theatre, Shoreditch (1844) *c*1935-6

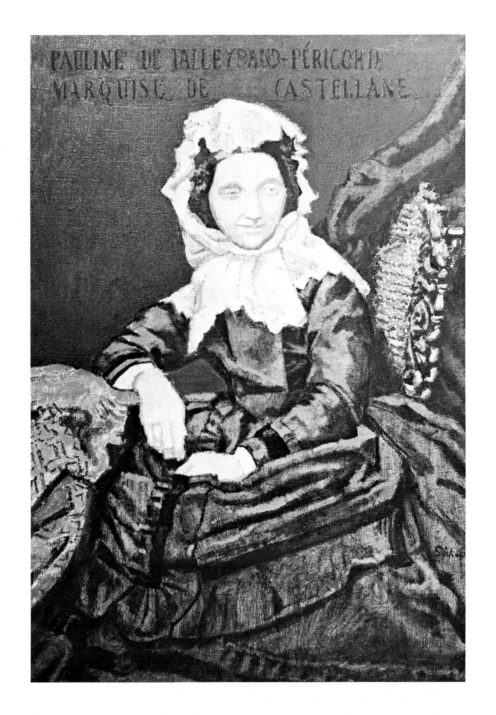

88
Princess Pauline de Talleyrand-Perigord, Marquise de Castellane *c*1937

92
The Rectory 1939

93
Queen Victoria and her Great-Grandchild *c*1940

Figure subjects

102
Pimlico *c*1937-8

Landscapes

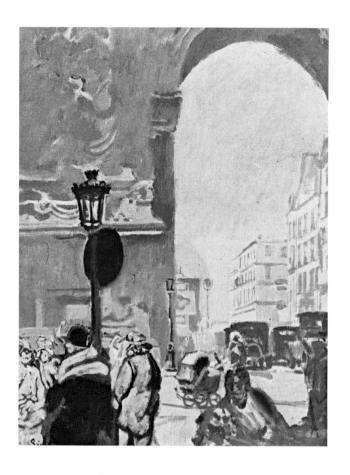

106
The Third Republic 1932-3

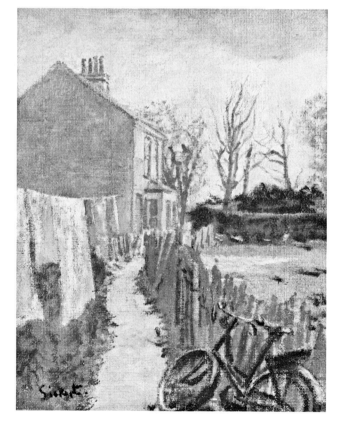

109
91 Albion Road c1937-8

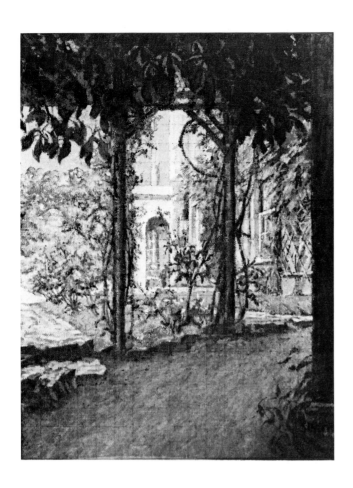

114
The Garden, St George's Hill House, Bathampton 1939-40

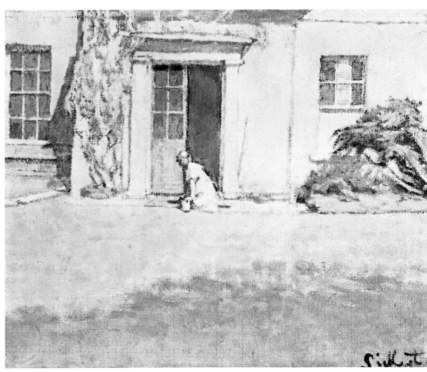

120
A Scrubbing of the Doorstep 1941

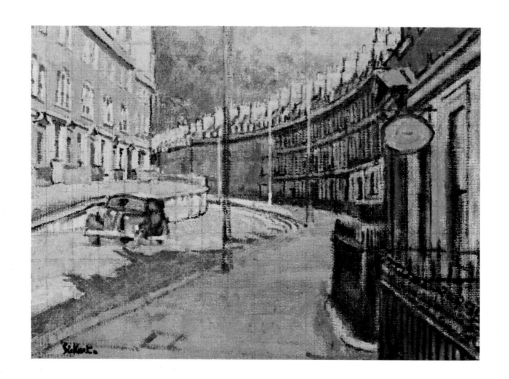

116
The Vineyards, Bath 1941

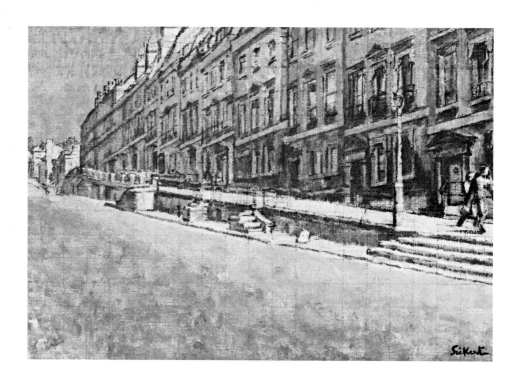

117
Bladud Buildings, Bath 1941

Catalogue of paintings

Wendy Baron

There is a tendency today to consider Sickert as two separate artists, the early and the late, each enthusiastically supported by a separate claque of devotees. Indeed, Sickert himself abetted this division of his *persona* when, in 1927, he chose to be known by his second Christian name, Richard, after a lifetime spent as Walter. It is now maintained that Walter Sickert has been studied, acclaimed and publicised in books and exhibitions at the expense of Richard Sickert. The *raison d'être* of this very exhibition is to redress the balance and perhaps advance the claim that the work of late Sickert has greater relevance to contemporary art than that of his younger namesake. Hitherto, retrospective exhibitions spanning the whole of Sickert's sixty year career as a painter could include only a handful of the greatest masterpieces from the last fifteen years. The chance to gather together a larger collection of the late works must be welcomed. For the first time since his death in 1942, the public will be able to see and judge these masterpieces (with the regrettable exceptions of two of his finest paintings, *The Raising of Lazarus* and *King George V and Queen Mary*) within the context of the daily production of his studio. However, the danger in exhibiting these late works separately is that their isolation may consolidate the impression that the early and the late artist are in opposition or rivalry.

It must, therefore, be emphasised here that the progress of Sickert's long painting career was continuous and that the late work evolved naturally and logically from his preoccupations and achievements from 1880 until 1926. He continued to develop the themes he had long since established. He still painted in the studio from source documents, although he used self-produced drawings less, and ready-made material (photographs or other artists' graphic work) more. His extensive use of studio assistants to paint his pictures in later years can be interpreted as a deliberate demonstration that he had won his life-long struggle to tame his medium by evolving a fool-proof and de-personalized system of production from the early stages of laying-in a design to the final touches of local colour. The distinctive qualities of his later style, for example the rawness of his handling and the boldness of his design, are presaged in his own earlier work. However, in his late paintings he pushed ideas he had formerly merely touched upon to unexpected conclusions.

What above all sets Sickert in old age apart, not from his own younger self but from the majority of his contemporaries, is that he continued to experiment, develop and evolve as an artist virtually until the day he died. He was not content to repeat the formulae of earlier successes but instead kept up his enquiries into the nature and practice of his craft with undiminished enthusiasm and energy. Thus, the latest phase of his career was no less fertile than earlier periods, and surprises continued until the end.

Sickert's fertility as a painter was extraordinary. Not only was the volume of his production prodigious, but his inventive powers were unflagging. This is amply demonstrated by a consideration of the range of his subject-matter. It is impossible to say whether his achievement as a painter of townscapes, portraits, theatrical subjects, interiors with figures or anecdotal subject pictures was the more considerable. He himself developed his interest in each of these fields with equal conviction, so that his production as a whole presents a rich and varied tapestry of tightly interwoven themes. Each of these themes is represented in his late work and examples are catalogued, under different section headings, below.

Section Headings

The task of assigning paintings to the appropriate headings was not always straighforward. For instance, should *Sir Thomas Beecham* (No 56) be listed as a

portrait or as a theatrical subject? Similarly *Conchita Supervia* (No 28). The former has here been classed as a theatrical subject because he is portrayed conducting, the latter as a portrait because her role is not stipulated. Is *Her Majesty's* (No 45) a contemporary theatre or an Echo? How should landscapes or interiors which, however peripherally, incorporate a self-portrait (Nos 3,5-7) be classified? And would some of the paintings here classed as landscapes be better defined as Echoes (eg Nos, 107,110,111)? It must, therefore, be emphasized that the categories used below are artificially designed to give structure to the catalogue. They do not reflect the artist's intentions and are thus open to argument and re-adjustment.

Physical Details

This is an exploratory exhibition and the whereabouts of several pictures became known to the selectors only through the kind response of private owners to advertisements in the press. First-hand examination of all the paintings included was not possible during the brief planning stage and thus full physical details of a few paintings were still unknown at the time the catalogue went to press. This explains the occasional lack of information on measurements and inscriptions. Measurements: height before width; inches stated first followed by centimetres in brackets. Inscriptions: given in full when known. Pictures known to be unsigned are stated as such in order to differentiate them from those paintings whose inscription details were still unknown when the catalogue was compiled. Abbreviations used: b = bottom; t = top; r = right; l = left; c = centre.

Provenance

Information on provenance is omitted. Many of the paintings catalogued were acquired by public collections, or by their present private owners' families, within Sickert's lifetime.

Exhibitions

Exhibition histories are not listed. However, the chronology of Sickert's late work is primarily charted by the many one-man exhibitions, often described as of recent paintings, held at the galleries of the several dealers who handled his pictures during the 1930s. Therefore, the first known exhibition of a painting, up to and including the year of his death (1942), is cited. These exhibition references are listed in abbreviated form (gallery, year and catalogue number) whenever fuller details, such as the precise content of an exhibition and the month of its opening, are given in the chronology. All exhibitions were in London unless otherwise stated, and all exhibitions listed without a title were one-man shows.

Literature

With the few exceptions of literature specific to a particular painting, references have been restricted to the standard monographs on Sickert's work:

Lillian Browse and R H Wilenski, *Sickert*, London, Faber, 1943 (abbreviated as Browse 1943).

Lillian Browse, *Sickert*, London, Rupert Hart-Davis, 1960 (abbreviated as Browse 1960).

Wendy Baron, *Sickert*, London, Phaidon, 1973 (abbreviated as Baron).

These monographs contain fuller information on the provenance, exhibition histories and literature of many of the paintings catalogued.

Portraits

Sickert can now be recognised as one of the greatest portrait painters of his time. As a pupil of Whistler, portraits entered his vocabulary of themes from the outset of his career and continued as a major element of his production until his death. Having quickly outgrown the portrait formula he had learned from Whistler, Sickert developed no single alternative but treated each sitter in an individual manner to produce, during the 1890s, the classic images of *George Moore, Israel Zangwill* and *Aubrey Beardsley.* His talents as a portraitist were, nevertheless, seldom acknowledged by his contemporaries. Most of his oustanding portraits were of friends (Mrs George Swinton, Jacques-Emile Blanche, Cicely Hey), of models (Mrs Barrett), or of flambouyant acquaintances (Signor de Rossi, Victor Lecour). None of his portraits of these sitters was commissioned and indeed, apart from one period during the 1890s of sustained but unsuccessful effort to make his name and earn a decent living as a portrait painter, Sickert seldom sought commissions. Therefore, until the late period, he seldom painted the great and the mighty. Then, as the grand old man of British painting who exhibited annually at the Royal Academy, portrait commissions began to come his way. Moreover, because he worked from photographs and found newspaper images ideal source documents, he could paint whomever he pleased, wherever he pleased. Thus, we have Sickert's unforgettable but unsolicited images of *Edward VIII* (Nos 29, 30) and of *George V* (No 15), as well as commissioned portraits of such well-known personalities as *Lord Beaverbrook* (No 22) and *Lord Castlerosse* (No 21).

The most obvious respect in which these late portraits differ from his earlier work in the genre is scale. In later years he favoured the life-size full-length, establishing the formula in 1927 with his portrait of *Rear-Admiral Lumsden* (No 10). In this, however, he was returning to a formula learned in his youth from Whistler. The pose of Lumsden is, indeed, a quotation from Whistler. Moreover, when considering Sickert's use of photographs as the basis for his late portraits, we should remember that he had used photographs as an occasional aid to portraiture throughout his career. The first documented example is his posthumous portrait of *Charles Bradlaugh at the Bar of the House of Commons* painted 1892-3 in which Sickert not only chose to represent his distinguished subject life-size and standing, but also acknowledged that the head had been based upon a photograph.

1
Lazarus breaks his fast *c*1927
Oil on canvas; 30 × 25 (76 × 63.5)
inscribed 'Lazarus breaks his fast' t.r.
First exhibited: Savile Gallery 1930 (7)
Literature: Browse 1960, pp 22,41,61,74, Col Pl XI; Baron, pp 169, 171,175,379, No 401, Fig 279
Lent by Mr and Mrs Eric Estorick

In his self-portraits Sickert, once an actor, always a *poseur,* delighted in compounding the enigmas of his personality by casting himself in a variety of roles. The Whistlerian dandy *(L'Homme à la Palette),* the introspective artist aged forty-seven, still playing the part of an *enfant terrible (The Juvenile Lead),* the flamboyant eccentric of the First World War *(The Bust of Tom Sayers),* became, in a magnificent trio of self-portraits conceived during the late 1920s, a figure whose patriarchal grandeur reflects the professional standing – as an elder of his tribe – which Sickert had by then achieved. With uninhibited arrogance, he borrowed the titles for these self-portraits from the bible. The old man, napkin tucked under his chin, ferociously attacking his food, was christened *Lazarus breaks his Fast.* The monumental close-up bearded head (No 2) was inscribed, in a large flowing hand, 'The Servant of Abraham'. *The Raising of Lazarus,* painted between 1929 and 1932, represents the creative as well as the chronological climax of these portrayals.
In all three portraits Sickert used photographs as his primary

documents. The titles of all three help the spectator to respond to them imaginatively. However, in *The Raising of Lazarus* (sadly not available for exhibition) the conceptual leap away from straight portraiture towards the realm of imaginative history painting was more precipitate. Sickert painted his work from a composite print of several photographs which recorded the weird scene presented by the awkward transportation of a life-size lay figure (which had reputedly once belonged to Hogarth) up the narrow gloomy staircase to his studio at Highbury Place, Islington. Sickert transformed Cicely Hey, who helped support the figure from below, into Lazarus's astounded sister; he transformed himself, directing operations from above, into the miracle-worker, Christ.

The story of Lazarus, risen from the dead, perhaps exerted a special fascination for Sickert at this period, symbolic of his own regeneration in 1927, following his third marriage the previous year, as Richard Sickert after a lifetime as Walter.

2

The Servant of Abraham 1929
Oil on canvas; 24 × 20 (61 × 51)
signed 'Sickert' t.r. and inscribed 'The Servant of Abraham' b.1.
First exhibited: Savile Gallery 1930 (28)
Literature: Browse 1960, pp 22,41,50,61,83,102, Pl 96; Baron, pp 169, 171, 380, No 405, Fig 283
Lent by the Trustees of the Tate Gallery

One of the trio of grand, patriarchal self-portraits of the late 1920s (see note to No 1). The Tate Gallery Catalogue, p 640, quotes information given to the compilers by Mrs Helen Lessore that Sickert conceived this portrait (painted from a photograph) as if it were part of a large mural decoration, and deliberately used a broad technique to demonstrate how he would have treated such a grand-scale commission. Miss Browse also perceived this and quoted Sickert's words: 'We cannot well have pictures on a large scale nowadays, but we can have small fragments of pictures on a colossal scale.'

3

The Front at Hove 1930
Oil on canvas; 25 × 30 (63.5 × 76)
signed and dated 'Sickert 30' b.1.
First exhibited: French Gallery 1931, 'Anthology of English Painting' (38)
Literature: Browse 1943, pp 31,63,Pl 64; Browse 1960, p 102; Baron, pp 177,388,No 447
Lent by the Trustees of the Tate Gallery

Rather in the spirit that Alfred Hitchcock chose to appear in walk-on parts in his own films, Sickert from 1930 onwards often included himself as an incidental figure in both his landcape paintings and his interior figure subjects. In *The Front at Hove,* painted during or soon after a visit to the resort, the man seated on the bench wearing a bowler hat and coat is a self-portrait. The woman may be Thérèse Lessore, his wife. The scene is a view of Adelaide Crescent, with Brunswick Terrace and The Lawns in the foreground. Sickert presumably painted from a photograph, and it was this habit that gave him the opportunity to incorporate self-portraits into these late paintings.

The Front at Hove has a subtitle: 'Turpe senex miles turpe senilis amor', a quotation from Ovid, *Amores*, I,ix,line 4, which means, 'An old soldier is a wretched thing, so also is senile love'. This is presumably a wry comment on the overtures made by the old man (Sickert aged seventy) towards the lady seated alongside on the bench. Sickert gave nearly all his late self-portraits allusive titles which do not, however, make explicit the fact that the artist has portrayed himself. Several examples are catalogued below. Among other paintings not included in the exhibition are *The Rural Dean* (a double portrait of Sickert and his wife out for a stroll) and *Home Life* of 1937 which shows the artist slipping off to his wine cellar at St Peter's-in-Thanet (both pictures currently of unknown whereabouts).

4

Self Portrait in Grisaille c1935
Oil on canvas; 27 × 10 (68.5 × 25.5)
unsigned
Literature: Browse 1960, p 100; Baron, p 380 under No 405 (wrongly listed as in the Tate Gallery)
Lent by the National Portrait Gallery

Many press photographs of the 1930s show Sickert wearing the loud check suit he sported on most public occasions. This portrait was perhaps painted from the photograph published in the *Daily Mirror*, 8 March 1934, or more probably from the one captioned 'RA Resigns', published in the *Star*, 21 May 1935.

Another self-portrait (present whereabouts unknown) depicts Sickert wearing the same suit together with his friend, the actress Gwen Ffrangcon-Davies (see Nos 41,42,43,50). Inscribed in capital letters 'GWEN FFRANGCON-DAVIES AND ANR' this double portrait shows the pair arriving together at the Private View of the Royal Academy in 1932. They were photographed in the *Daily Sketch*, 30 April 1932, and less than three months later Sickert's double portrait painted from this document was exhibited in London. The *Sunday Graphic*, 24 July 1932, reproduced the painting and the original photograph. It is interesting that Sickert also painted the double portrait in monochrome, choosing green as his colour rather than the grey of the single portrait exhibited here.

5

A Domestic Bully c1935-8
Oil on canvas; 32¼ × 29¼ (82 × 74.5)
signed 'Sickert' b.1.
First exhibited: National Gallery 1941 (11)
Lent by a Private Collector

One of two versions of the same interior, the kitchen of Sickert's house at St Peter's-in-Thanet. The other version, entitled *The Coffee Mill*, is catalogued as No 101.

In *A Domestic Bully* Sickert has added a self-portrait on the right (hence the title) and a female figure seated and reading a newspaper in the background.

6
Home Sweet Home
Oil on canvas; 34½ × 28½ (87.5 × 72.5)
signed 'Sickert' b.r.
First exhibited: Leicester Galleries 1942, 'Retrospective Collection
of Drawings and Recent Paintings by Walter Richard Sickert' (111)
Literature: Browse 1960, p 110; Baron, pp 178,388,No 448
Lent by Worthing Art Gallery and Museum

The date of this painting was cited as 1939 in the Leicester Galleries
1942 catalogue. However, it shows Sickert in the distance seated in
the front porch of his house at St Peter's-in-Thanet where he lived
from December 1934 until December 1938. He might have finished
the painting after his move to Bathampton, but probably began it in
St Peter's.

7
The Invalid c1939-40
Oil on canvas; 25 × 30 (63.5 × 76)
signed 'Sickert' b.r.
First exhibited: Leicester Galleries 1940 (2)
Literature: Baron, pp 178,387,388,No 450
Lent by a Private Collector

The picture shows Sickert, in back view, stomping up his garden at
Bathampton (see Nos 112,114,115), stick in hand, to survey the
view.

8
Reading in the Cabin 1940
Oil on canvas; 17 × 31 (43 × 78.5)
unsigned
First exhibited: Leicester Galleries 1942, 'Retrospective Collection
of Drawings and Recent Paintings by Walter Richard Sickert' (107)
Lent by the Methuen Collection

This curiously angular double portrait portrays Sickert, wearing one
of his favourite peaked caps, and his wife Thérèse Lessore. The cap,
with its nautical flavour, presumably suggested the title of the
painting.

9
The Rt Hon Winston Churchill c1927
Oil on canvas; 18 × 12 (45.5 × 30.5)
unsigned
First exhibited: Savile Gallery 1928 (10)
Literature: Browse 1960, pp 21,99; Baron, pp 171,174,380,No 403,
Fig 281
Lent by the National Portrait Gallery

Winston Churchill (1874-1965), prime minister 1940-5 and 1951-5,
was a keen amateur painter. Churchill's mother-in-law, Lady
Blanche Hosier, had been a friend of Sickert and perhaps this
connection led him to take some lessons in painting from Sickert at
the time this portrait was painted, while he was Chancellor of the
Exchequer in Baldwin's Government. Churchill returned the com-
pliment by painting a tea-party at Chartwell, including Sickert and
his wife among the guests.

10
Rear Admiral Walter Lumsden, CIE, CVO 1927-8
Oil on canvas; 95½ × 35¼ (242.5 × 89.5)
unsigned
First exhibited: Royal Academy 1928, 'Summer Exhibition' (652)
Literature: Browse 1960, p 41; Baron, pp 173-4,380,No 402, Fig 277
Lent by the Minneapolis Institute of Arts

The first of Sickert's late, life-size, full-length portraits of persons of
distinction. The pose, three-quarters back view with the head turned
more fully towards the spectator, is strongly reminiscent of
Whistler's more formal full-lengths. Although this portrait set the
formula for later commissioned examples, it was not itself
commissioned. Indeed, the sitter was virtually solicited by Sickert.
The story goes that during one of his swims at Brill's Baths in
Brighton, the artist was so intrigued by the fine and liberally
tattooed body of a fellow-swimmer that he asked the unknown man
to come and pose for him. He was greatly surprised when his sitter
turned up dressed in the uniform of an Admiral. By then Admiral
Lumsden (1865-1947) had, in fact, long since retired from the Navy.
This portrait was submitted, unfinished, to the Royal Academy in
1927 but rejected. It was accepted in 1928 and voted Picture of the
Year.

11
Viscere Mie 1927-8
Oil on canvas; 24 × 17¼ (61 × 44)
signed 'Sickert A.R.A.' b.r.
First exhibited: Savile Gallery 1928 (8)
Literature: Baron, pp 177,388 under No 449
Lent by a Private Collector

The background to the mother and child group is
Il Cannaregio, Venice. Denys Sutton, *Walter Sickert*, 1976, p 236
suggested that Sickert may have visited Venice in 1930 when his
work was well represented at the Biennale. However, so far as is
known, when *Viscere Mie* was painted Sickert had not been in Venice
since 1904. During his late years he seems to have recalled this
particular corner of the city more often than any other (see also Nos
110,111). He perhaps worked from early drawings as well as from
photographs. The mother and child group (unidentified) were
certainly painted from a photograph which the owner of the
painting remembers having seen. If the background was an artificial
backdrop (as was common in Sickert's portraits), in choosing Venice
Sickert was reviving his early usage of aspects of this city to set off
the bold silhouettes of such figures as *Israel Zangwill* and *Mrs
Swinton*.
The implications of the title (in translation 'my bowels' or 'entrails')
are a mystery.

12
Hugh Walpole 1928
Oil on canvas; 16⅞ × 16½ (43 × 42)
signed and dated 'Sickert 1928' b.r.
First exhibited: London Group, January 1929 (19)
Literature: Rupert Hart-Davis, *Hugh Walpole.
A Biography,* 1952, pp 299-301, rep. facing p 300;Baron, p 381
under No 406
Lent by the Fitzwilliam Museum, Cambridge

One of two portraits by Sickert of Hugh Seymour Walpole
(1884-1941), novelist, knighted 1937. Walpole admired and collected
Sickert's work and wrote the preface to Sickert's exhibition at the
Savile Gallery in February 1928. In his journal (quoted by Hart-
Davies), Walpole referred to the Sickert portrait, begun in October
1928, and noted after the second sitting: 'He did nothing whatever,
complaining of the light. It's no use my being fussed by this. He's
apparently going to take weeks and weeks and I must endure it.'
Sickert painted this portrait from life sittings and from a photograph
taken by a professional. It was done at his studio in Islington and the
artist's decision to portray the novelist against what appears to be a
sea-side backdrop is not explained. Although the portrait was com-
missioned, the sitter evidently let the artist do what he liked. Hart-
Davies quoted Walpole's revealing and moving reflections on the
artist following his experience as a model. However, Walpole's
opinion of the portrait is not recorded. Certainly, Sickert produced
an uncompromising image, with the close-up head, staring through
light-reflecting glasses, contrasting strangely in scale and mood with
the background figures.

13
Hugh Walpole 1929
Oil on canvas; 30 × 25 (76 × 63.5)
signed and dated 'Sickert 1929' b.c.r.
First exhibited: Savile Gallery 1930 (4)
Literature: Browse 1960, pp 21,112; Andrew Forge, *Listener*,
7 October 1965, 'Sickert's portrait of Hugh Walpole'; Baron,
pp 168,169,171,174-5,177,381,No 406, Fig 282
Lent by Glasgow Art Gallery and Museum

Sickert's second portrait of Hugh Walpole, painted a year after the
commissioned version. It was presumably painted entirely from
photographs and from memory, for the artist's own pleasure.
Perhaps Sickert felt that the earlier, more formal likeness failed to
express the essence of his subject; or possibly he was captivated by
the purely pictorial possibilities of a photograph of Walpole he had
to hand, but had not used for the commissioned portrait. The 1929
portrait of Walpole is not only one of Sickert's finest achievements
but one of the most arresting and remarkable British portraits of this
century.

14
Dr Cobbledick 1929
Oil on canvas; 22 × 17 (56 × 43)
unsigned
First exhibited: Royal Academy 1930, 'Summer Exhibition' (256)
Literature: Browse 1960, p 82
Lent by Lady Elliot

Dr A S Cobbledick was Sickert's eye-specialist. Due to his
successful treatment Sickert was able to continue painting until his
death. The portrait was given to the sitter in lieu of medical fees.
Dr Cobbledick was also an amateur painter and attended some of
Sickert's classes at Highbury Place.

15
King George V and his Racing Manager c1927-30
Oil on canvas; 18½ × 18½ (47 × 47)
signed 'Sickert' b.r. and inscribed 'By Courtesy of Topical Press/11
and 12, Red Lion/Court E.C.4/Aintree − 25.3.27'
First exhibited: London Group, October 1931 (142)
Literature: Baron, p 382 under No 408
Lent by Her Majesty, Queen Elizabeth, The Queen Mother

One of two portraits by Sickert of H M King George V (reigned
1910-1936), both painted from press photographs and both two-
figure groups. The second portrait, which was unavailable for exhi-
bition here, shows the King with Queen Mary framed by the
window of their car during one of the Jubilee Drives in 1935. It was
ready for exhibition at the Leicester Galleries during the summer
under the title *His Majesty*. In contrast to the 1935 portrait of the
King, dressed in the uniform of Admiral of the Fleet on a formal
occasion, the painting exhibited here depicts him off-duty, accom-
panied by Major Featherstonhaugh, manager of his racing stables.
The informality of its subject is emphasized in the alternative title,
A Conversation Piece at Aintree, used when the painting was
exhibited at the Beaux Arts Gallery in 1932 and again (by then on
loan from Sylvia Gosse) at the Carnegie Institute, Pittsburgh
Annual International Exhibition in 1933. Indeed, when the Beaux
Arts Gallery offered the portrait as a gift to the Glasgow Art Gallery
in 1931, the city corporation turned it down as lacking in majesty.
This painting is generally dated 1927, when the photograph, so
frankly acknowledged by Sickert, was published in the *News
Chronicle*. However, it was probably painted from this earlier docu-
ment towards the end of the date-bracket 1927-30. According to a
press cutting, the portrait was on view at the Lefevre Gallery at
Christmas 1930, but I have found no catalogue to check this detail.

16
Lady in Blue. Portrait of Lady Berwick 1933
Oil on canvas; 60 × 36 (152.5 × 91.5)
signed 'Sickert' t.l.
Literature: Merlin Waterson, *National Trust Studies*, 1981, 'Lady
Berwick, Attingham and Italy'
Lent by the National Trust from Attingham Park

Teresa Hulton, daughter of Sickert's close friends from his early
visits to Venice, Mr and Mrs William Hulton, married Thomas, 8th
Baron Berwick in Venice in 1919. Translated to Shropshire, she set
about restoring the sadly neglected house and grounds at Attingham
with a professional competence and sensitivity learned from her
mother. Sickert painted her portrait, and that of her sister Gioconda
Hulton (present whereabouts unknown) in 1933. Merlin Waterson
recounts the full story of Sickert's relationship with Lady Berwick
and her parents. He quotes Lady Berwick's recollections of the
Sickert portraits: 'We went to his studio in Barnsbury Park & he
took some photos. From these he did two large canvasses, three
quarter length, rather over life size, the one of Gioconda, standing,
in grisaille, mine in a figured blue dress, also standing, a hat on a
chair nearby. . . . No one could call it a portrait, it is a fantasia in a
characteristic subdued colour scheme. Both pictures . . . were signed
by Sickert . . . on 10 January 1934.'
Mr Waterson reproduces the portrait, in colour, p 55, noting that

Lady Berwick considered it unsatisfactory as a likeness and insisted that its original, non-specific, title should be retained.

17
Diana Forbes-Robertson c1933
Oil on canvas: 40 × 25 (101.5 × 63.5)
First exhibited: Royal Academy 1933, 'Summer Exhibition' (242)
Lent by a Private Collector

The sitter is the youngest daughter of Sir Johnstone Forbes-Robertson, the actor (see No 79), who was an early friend of Sickert and his parents. She married the American author, Vincent Sheen.

18
Peggy Ashcroft in her Bathing Costume c1934
Oil on canvas; 29 × 26 (73.5 × 66)
signed 'Sickert' b.l.
First exhibited: Leicester Galleries 1934 (15) as *Peggy Ashcroft*
Literature: Baron, pp 174,383, No 413
Lent by Cyril M E Franklin, Esq.

Sickert painted Dame Peggy Ashcroft (b 1907) perhaps more often than any other actress. They first met in 1932, when Peggy Ashcroft was playing at the Old Vic. Sickert, who himself began his career as an actor, never lost his love of theatre in all its forms, and was a great supporter of both the Old Vic and Sadlers Wells. He not only painted Peggy Ashcroft in many of the parts she played during the first half of the 1930s (see Nos 40,46,47,48,49,51), he also painted several portraits of her. In this, off-duty, portrait he has brilliantly preserved the instantaneous snapshot quality of the document from which it was probably painted.

19
Variation on Peggy c1934-5
Oil on canvas; 22 × 27¾ (56 × 70.5)
signed 'Sickert' b.r. and inscribed 'Variation on Peggy' b.l.
First exhibited: Beaux Arts Gallery 1935 (8)
Literature: Baron, pp 177,388 under No 449
Lent by a Private Collector

Sickert painted this portrait of Peggy Ashcroft from a photograph taken while she was on holiday in Venice which was published in the *Radio Times*. The background represents Sta. Maria della Salute. The figure, painted in a bumpy green monochrome, recalls the mother and child group also silhouetted against a Venetian background in *Viscere Mie* (No 11).

20
Sir James Dunn, Bt. 1934
Oil on canvas; 54 × 36 (137 × 91.5)
signed 'Sickert' b.l.
Literature: Baron, p 381 under No 407
Lent by the Beaverbrook Art Gallery, Fredericton, NB, Canada
(Gift of the Sir James Dunn Foundation)

Sickert's financial situation was bleak during the early 1930s when the Depression hit the art market. Sir James Dunn (1875-1956), the Canadian financier who was created a baronet in 1921, was one of several friends who came to the artist's assistance. Having met and liked Sickert in 1932 or thereabouts, he not only bought two of Sickert's paintings but, in 1933 or 1934, he commissioned a series of

twelve portraits and payed the artist £250 each, in advance. The series was to include three portraits of himself (of which only two were painted, one being this picture, the other a full-length standing portrait belonging to the Beaverbrook Canadian Foundation which was unavailable for exhibition); one of Lord Beaverbrook (No 22); one of Viscount Castlerosse (No 21); one of Lord Greenwood; one of his secretary (to become his third wife in 1942 and subsequently to marry Lord Beaverbrook), Miss Marcia Christoforides (also unavailable for exhibition); and possibly Sickert's portrait of Edward VIII (No 29) was added as an afterthought to the original series. The story of the commission is related by Lord Beaverbrook in *Courage. The Story of Sir James Dunn*, 1961. Sickert did not complete the series, delayed over finishing those he had begun, and even left London for St Peter's-in-Thanet without informing his patron. Sir James followed the artist to Kent but was refused admittance. Miss Christoforides had more success and succeeded in wresting two nearly completed portraits from the artist, bringing them back to London strapped to the side of her car. Sickert exhibited the life-size standing portrait of *Sir James Dunn* at the Royal Academy in 1934 and that of *Miss Christoforides* in 1935.

21
Viscount Castlerosse 1935
Oil on canvas; 83 × 27⅝ (211 × 70.2)
signed and inscribed 'Sickert/St Peter's-in-Thanet' b.r.
First exhibited: Royal Academy 1935, 'Summer Exhibition' (477)
Literature: Browse, pp 21,87; Baron, pp 171,173,174,381,
No 407,Fig 285
Lent by the Beaverbrook Canadian Foundation, Beaverbrook Art Gallery, Fredericton, NB, Canada

See note to No 20. Viscount Castlerosse, later the 6th Earl of Kenmare (1891-1943), was a friend of Lord Beaverbrook, director of several newspapers and a well-known gossip columnist. In his own gossip column in the *Sunday Express,* 12 May 1935, Lord Castlerosse told how he never saw the portrait before its exhibition at the Royal Academy: 'All I did was to have luncheon with Sir James Dunn, and there I met Mr. and Mrs. Sickert.' He went on: 'Mrs. Sickert took a snapshot or two, and that was all that was asked of me.' Sickert apparently told Castlerosse that his method was to return to the spirit of traditional eighteenth century practice when portrait artists did not expect their sitters to pose formally but instead observed them as they talked together. The portrait was the talking point of the exhibition. Its colours, bright arbitrary blue, pink and chocolate brown, provoked comment in every review. Even the *Tailor and Cutter* complained of the cut of the suit and the colour of its cloth. Sir James Dunn, who had commissioned and paid for the picture, attempted to reject it because of the artist's use of brown, a colour he considered lacked distinction. The artist and sitter at last persuaded Sir James that the colour was in fact cinnamon. Sickert succeeded in capturing the essence of his sitter's character, the man who was described in the *Bystander* (22 May 1935) as 'florid, opulent, merry, the easy familiar of London's leading head-waiters' and in the *Manchester Guardian* (4 May 1935) as the 'Playboy of the West End World'.

22
Lord Beaverbrook 1935
Oil on canvas; 69⅜ × 42¼ (176 × 107.5)
signed and dated 'Sickert/1935' b.r.
Literature: Browse, pp 21,47; Baron, 381 under No 407
Lent by the National Portrait Gallery

See note to No 20. This portrait of William Maxwell Aitken, first
Baron Beaverbrook (1879-1964), painted three-quarter length
against an artificial backdrop of the sea at St. Peter's-in-Thanet, was
rejected by the Royal Academy in 1935 because of its colossal scale.
It was painted from a photograph which, together with the corres-
pondence between artist and sitter relating to the portrait, are
preserved with the Beaverbrook papers in the Records Office of the
House of Lords.

23
Sir Alec Martin, KBE 1935
Oil on canvas; 55 × 42½ (140 × 108)
signed 'Sickert' b.l.
Literature: Browse 1960,p 103; Baron, pp 171,174,383,No 415
Lent by the Trustees of the Tate Gallery

Sir Alec Martin (1884-1971) was Sickert's executor and, until 1958,
chairman of Christie, Manson & Woods. Sir Alec, like Sir James
Dunn, came to Sickert's aid in the early 1930s. In 1934 he organized
a subscription fund 'to enable Mr Sickert to continue his work free
from financial anxiety'. In 1935 he commissioned three portraits
from Sickert, of himself, his wife (No 24) and his youngest son (No
25). He and his wife were both painted at Sickert's house in St
Peter's which was near the Martins' house at Kingsgate. Thérèse
Lessore took snapshots of all three sitters, during the course of
sittings from life.

24
Lady Martin 1935
Oil on canvas; 55 × 42½ (140 × 108)
signed 'Sickert' b.l.
Literature: Browse 1960, p 103; Baron, pp 174,383 under No 415
Lent by the Trustees of the Tate Gallery

Lady Martin (*née* Ada Mary Fell) married Sir Alec in 1909.

25
Claude Phillip Martin 1935
Oil on canvas; 50 × 40 (127 × 101.5)
signed and inscribed 'Sickert, Hauteville' b.r. and 'To our dear Alec'
b.l.
Literature: Browse 1960,p 103; Baron, pp 174,383 under No 415
Lent by the Trustees of the Tate Gallery

This portrait was begun in the garden of the Martins' house,
Marandellas, Kingsgate, but finished and inscribed at Sickert's
studio at Hauteville, St Peter's-in-Thanet.

26
Bude: Girl with Two Dogs c1935
Oil on canvas; 30½ × 22¼ (77.5 × 56.5)
signed 'Sickert' b.l.
Lent by a Private Collector

The subject of this portrait, clearly painted from a photograph, is
unidentified.

27
The Row c1935
Oil on canvas; 28 × 22 (71 × 56)
signed 'Sickert' b.r.
First exhibited: Leicester Galleries 1938 (2)
Lent by a Private Collector

The girl on horseback portrayed in this painting has not been
identified. Sickert obviously painted from a photograph.

28
Conchita Supervia c1935
Oil on canvas; 24 × 15 (61 × 38)
inscribed 'Conchita Supervia' across top edge
First exhibited: Leicester Galleries 1936 (42)
Lent by a Private Collector

Conchita Supervia (1895-1936), the Spanish-born mezzo-soprano,
was British by marriage and a popular prima donna at Covent
Garden during the 1930s. She was especially noted for her roles in
operas by Rossini and for her singing of Carmen. Sickert may well
have heard her sing, but probably painted this portrait from a
photograph in the press.

29
HM King Edward VIII 1936
Oil on canvas; 72¼ × 36¼ (183.5 × 92)
signed 'Sickert' b.r.
First exhibited: Leicester Galleries 1936, 'Summer Exhibition' (129)
AS HIS MAJESTY THE KING
Literature: Browse 1960, p 87; Baron, pp 173,382,No 409, Fig 287
Lent by the Beaverbrook Canadian Foundation, Beaverbrook Art
Gallery, Fredericton, NB, Canada

This portrait formerly belonged to Sir James Dunn who perhaps
took it in lieu of one of the uncompleted commissioned portraits for
which he had already paid. It is one of the few portraits of Edward
VIII painted during his brief reign from January 1936, when he
succeeded his father, until December of that year when he abdicated
in favour of his younger brother and was created Duke of Windsor.
The portrait shows the King, in the uniform of the Welsh Guards,
arriving at a Church Parade Service of the Welsh Guards on St
David's Day, 1 March 1936. Sickert painted his portrait in a
fortnight, working from a photograph taken by a freelance photogra-
pher, Harold J Clements. The portrait was greatly admired as an
outstanding likeness; indeed, Sickert's artistry was so loudly praised
that Mr Clements was offended at having been forgotten as the
author of the original document.

30
HM King Edward VIII 1936
Oil on canvas; 72 × 36 (183 × 91.5)
signed 'Sickert' b.r.
First exhibited: possibly Beaux Arts Gallery 1937 (13) as *The Duke
of Windsor*
Literature: Baron, pp 173,382 under No 409
Lent by the Welsh Guards

This portrait is virtually a replica of No 21, the most obvious difference being that the signature is placed in front of, instead of behind, the King's foot. Sickert's motive for painting this second portrait is not known. Perhaps he wished to replace a painting he had been forced to relinquish to Sir James Dunn. However, if so, he soon lost interest in the picture because he gave it to a friend, Mrs N G McLean. The Welsh Guards were able to acquire it at auction in 1963.

31
The Hon Lady Fry c1935-8
Oil on canvas; 45 × 50 (114.5 × 127)
signed 'Sickert' t.r.
Literature: Baron, pp 170,383,No 414
Lent by the Royal Pavilion, Art Gallery and Museums, Brighton

A portrait of Alathea, Lady Fry, a daughter of Lord Burghclere, commissioned by Sir Geoffrey Fry, the sitter's husband. Sir Geoffrey did not expect so unconventional a portrait. Apparently, having waited some months without having heard from the artist, Lady Fry was surprised one morning by a photographer who arrived to invade the privacy of her bedroom as she was reading a newspaper in bed. Then there was silence again from Sickert until Sir Geoffrey received a message to meet his wife's portrait off a certain train. This comic story is not merely evidence of Sickert's eccentricity. It also reveals how he used the camera to trap, not a mere likeness, but a living, natural, if unconventional aspect of his sitter such as he could never have captured in formal sittings.

32
Portrait of Mark Oliver c1937
Oil on canvas; 47½ × 26¼ (120.5 × 66.5)
signed 'Sickert' b.l.
Lent by a Private Collector

Mark Oliver, who joined Sickert's painting class in Highbury in 1927, ran the Savile Gallery with R E A Wilson. This gallery strongly supported Sickert during the later 1920s when they arranged five major exhibitions of his work, two in 1926, and one each in 1927, 1928 and 1930. The gallery was a victim of the Depression, although R E A Wilson continued to deal and exhibit Sickert's work during the 1930s. This portrait was probably painted at St Peter's-in-Thanet.

33
Alexander Gavin Henderson, 2nd Lord Faringdon
Oil on canvas; 91 × 33½ (231 × 85)
signed 'Sickert' b.l.
Lent by Lord Faringdon

A commissioned portrait, painted from a photograph.

34
A H C Swinton 1938
Oil on canvas; 29½ × 24½ (75 × 62)
signed 'Sickert' t.r.
Lent by Major General Sir John Swinton

Brigadier Alan H C Swinton, MC, was the son of Sickert's great friend Mrs George Swinton (1874-1966), the talented singer. Sickert met Mrs Swinton in 1905 and painted her many times thereafter. In a letter written by Sickert to Ethel Sands in 1914 he reported: 'Mrs Swinton came to tea today. Poor dear, her boy Alan is just going out as an officer having had a year's training is it? at Sandhurst. He is a professional soldier. What a début! If fate ever allows it to be more, poor child.'

Brigadier Swinton survived and, in 1970, gave me details of how his portrait came to be painted by Sickert: 'It was painted in 1938 from a photo taken by his wife, when one day in that year, my Mother and I drove down to Broadstairs to have a most uproarious luncheon with them. She took several photographs, and I left my tunic with him, and perhaps my medals, but I do not remember this point.'

35
Portrait of Wendela Boreel c1938
Oil on canvas; 30¼ × 22 (77 × 56)
signed 'Sickert' b.l.
Lent by Mrs Valerie Bather

Wendela Boreel, a contemporary of Marjorie Lilly at the Slade, became a pupil of Sickert during the First World War. In 1924 she married L G Wylde, whereupon she and her husband became discerning collectors of Sickert's work. She remained a friend of Sickert until his death, as is testified by this portrait.

36
Underpainting for Portrait of Thérèse Lessore
Oil on canvas; 30 × 20 (76.2 × 50.8)
unsigned
Lent by University College London

Said to be Sickert's last portrait of his third wife, the painter Thérèse Lessore, who died three years after her husband in 1945. She was born in Brighton in 1884 into a family of artists. Her father was Jules Lessore, the painter and etcher, who had settled in England in 1871. Although not a founder-member of the London Group, she was elected before its first exhibition in March 1914, and before Sickert's resignation from the Group. Indeed, Sickert chaired the meeting at which she was elected. Sickert claimed in 1918 that he first noticed her work at the Allied Artists' Exhibition of 1912 where he had been 'profoundly elated' by her painting of a vegetable market. In his review (*New Age*, 28 May 1914) of the exhibition of 'Twentieth Century Art' at the Whitechapel Art Gallery, Sickert wrote: 'she will always appear to be the most interesting and masterful personality of them all'. Reviewing the London Group exhibition (*Burlington Magazine*, January 1916) he confessed: 'The artist who has always thrilled me in these and kindred groups is Thérèse Lessore.' In *Art and Letters*, I,No 3, January 1918, he devoted an entire article to her, reprinted in November as the preface to her one-woman exhibition at the Eldar Gallery. By this time Sickert and Thérèse Lessore were close friends, so that when Christine, Sickert's second wife, died in Dieppe in 1920 she went out to France to help Sylvia Gosse care for the distraught widower. They married in 1926.

Thérèse Lessore looked after Sickert with total devotion in later years. Together with other painters and pupils of Sickert, in particular Sylvia Gosse, she assisted her husband in the studio, laying-in his paintings on canvases which she had carefully prepared with gesso primings. Their work during these years is often closely similar. The resemblance is not surprising considering that they

painted as a team, with Sickert sometimes doing no more than direct operations and add his signature to a painting together with a few final touches of colour. Moreover, Thefèse Lessore did not act as a mere cipher. She had a positive influence upon Sickert's style and method, particularly when painting town and landcapes.

37
Mrs Anna Knight 1941-2
Oil on canvas; 60 × 30 (152.4 × 76.2)
unsigned
Literature: Browse 1960, p 103
Lent by the Trustees of the Tate Gallery

The Tate Gallery Catalogue, p 638 quotes information that this portrait, begun in Mrs Knight's home in Bath, was given up when Sickert succumbed to his last illness. It was painted direct from the sitter, without the use of preliminary photographic documents, which accounts for its striking dissimilarity from Sickert's other late works. This portrait is one of several paintings which are claimed to be Sickert's last work. Because he always worked on several paintings at the same time, it is possible that all these claims are true.

Theatrical subjects

Sickert began adult life as an actor, spending the years between 1877 and 1881 working in repertory companies and often touring the provinces to perform a variety of minor roles in the *pot pourri* of scenes from famous plays presented each night. Although he realised his true vocation by the age of twenty-one, Sickert never lost his love and knowledge of the stage. Every form of theatrical presentation captured his interest. In the 1880s he introduced the cockney music hall as a subject for painting into British art. These early paintings represented the stage and artistes as well as the plush, plaster and gilt music hall interiors filled with spectators. From the 1890s onwards he more usually concentrated on the audience and omitted explicit reference to the stage. However, from time to time throughout his career, and especially when painting more conventional theatrical subjects, he portrayed the stage in isolation. One painting of 1898, representing Miss Hilda Spong in Pinero's *Trelawny of the Wells* foreshadowed not only this characteristic but also aspects of the stylization and the working method of Sickert's late theatrical subjects. To achieve his life-size, close-up, sharply focussed portrait of Miss Spong, isolated on the set and visualised as a pattern of flat shapes and colours, Sickert worked primarily from a photograph he had taken of the actress on stage.

Sickert continued to paint theatrical subjects, music halls in London and Paris, the odd concert or cinematograph, for the next thirty years, but it was not until he lived in Islington and close to Sadlers Wells that his interest in painting the classical theatre intensified. He no longer painted theatre interiors and their audiences, but concentrated entirely upon the scene on stage. Although he sometimes made drawings from which to paint, he more usually brought a photographer with him to the theatre to take photographs when a scene particularly appealed to him. When, at the end of 1934, he moved out of London to St Peter's-in-Thanet, he had to rely on newspaper and publicity photographs. He

was thus able to follow and record the careers on stage of his favourite actors and actresses even when he missed the actual performances.

38
The Plaza Tiller Girls 1928
Oil on canvas; 30 × 25 (76 × 63.5)
signed and dated 'Sickert 1928' b.r.
First exhibited: Savile Gallery 1930 (17)
Literature: Browse 1960,pp 41,82,Pl 94; Baron,pp 175,384,No 420
Lent by a Private Collector

The Plaza Tiller Girls were a fashionable cabaret troupe in the 1920s. Sickert painted a second version of this subject, also dated 1928 but inscribed bottom left instead of right (present whereabouts unknown). Some ten years later he returned to the theme of a chorus line in *High Steppers* (No 57).

39
Sir Nigel Playfair as Tony Lumpkin 1928
Oil on canvas; 70 × 49 (178 × 124.5)
signed 'Sickert' t.r.
First exhibited: Royal Academy 1929, 'Summer Exhibition' (388)
Literature: Browse 1943,p 63,Pl 63; Baron, pp 176,384,No 421
Lent by Giles Playfair, Esq.

Sir Nigel Playfair appeared as Tony Lumpkin in Goldsmith's *She Stoops to Conquer* at the Lyric Theatre in August 1928. The portrait was commissioned as a gift for Sir Nigel from his fellow-actors and workers and presented to the sitter in January 1929 to celebrate the tenth anniversary of his management of the Lyric Theatre, Hammersmith. Sickert, in his turn, gave the money subscribed to the Sadlers Wells Rebuilding Fund.
Emmons, Sickert's pupil and biographer, reported (pp 212-13) that Sickert asked Alfred Munnings (who specialised in equestrian subjects) for a sketch to show him the proper distribution of mud splashes on the boots of a postilion, a curious concern for detail in an otherwise broadly handled painting of a theatrical, not a real, event.

40
Peggy Ashcroft as Rosalind: 'Wear this for me' c1932
Oil on panel; 8¾ × 7¾ (22 × 19.5)
signed 'Sickert' b.r. and inscribed 'WEAR THIS FOR ME' t.l. (all inscriptions faint)
Literature: Baron, p 385 under No 423
Lent by a Private Collector

Sickert made several paintings and (most unusually at this period) drawings of Old Vic and Sadlers Wells Company productions in 1932-3 when Peggy Ashcroft played the leading roles. Shakespeare's *As You Like It* was performed from September to October 1932 with Peggy Ashcroft playing Rosalind, William Fox playing Orlando and Valerie Tudor playing Celia. The scene represented in this little sketch (which once belonged to Hugh Walpole) is when Rosalind gives Orlando a chain from her neck, saying 'Wear this for me'. A larger and more finished version of this subject is in the Government Art Collection.

41
Miss Gwen Ffrangcon-Davies as Isabella of France: La Louve 1932
Oil on canvas; 96½ × 36¼ (244.5 × 92)
signed 'Sickert .p.' b.l., 'BERTRAM/PARK phot.' b.r. and 'LA LOUVE' along lower edge
First exhibited: R E A Wilson's Gallery 1932 (no catalogue)
Literature: Browse 1960,p 102; Baron, pp 176,383,No 416,Fig 288
Lent by the Trustees of the Tate Gallery

Acquired by the Tate Gallery in the year of its execution. Sickert much admired Gwen Ffrangcon-Davies (b 1896) as an actress and the two became friends (see note to No 4). Miss Ffrangcon-Davies told the compiler of the Tate Gallery catalogue that Sickert had found the photograph on which he based this painting in her albums. It was taken by Bertram Park at a dress-rehearsal of a Phoenix Society production of Marlowe's *Edward II* which was privately performed on 28 November 1923. Sickert did not see the production, but freely translated the photograph nearly ten years later. The title *La Louve* (she-wolf) was given to Isabella of France because of her fierce character. Together with young Mortimer she secured the downfall of the king who, in one passage of the play, exclaimed of the crown:
'tis for Mortimer, not Edward's head,
For he's a lamb, encompassed by wolves.

42
Gwen Ffrangcon-Davies in The Lady with a Lamp c1932-4
Oil on canvas; 48 × 27 (122 × 68.5)
signed 'Sickert' b.l.
First exhibited: Leicester Galleries 1934 (14)
Literature: Baron, p 383 under No 416
Lent by a Private Collector

Gwen Ffrangcon-Davies played the part of Florence Nightingale in *The Lady with a Lamp* (not *the Lamp* as usually published) on tour in the autumn of 1929, having previously played the part of Elizabeth Herbert in the same play in January 1929 at the Arts and Garrick Theatres. In this painting she is seen as Florence Nightingale, under which title the work was exhibited in the Carnegie Institute, Pittsburgh 1938 International Exhibition (122). The painting was done from a photograph. There is no record of Sickert having seen this play.

43
The Victor
Oil on canvas; 19 × 16¾ (48 × 42.5)
signed 'Sickert' (in pencil) mid r. and inscribed 'To Miss Ffrangcon-Davies − Gwen and her audience' (in faded red ink) b.l.
Literature: Browse 1960,p 98; Baron, p 383 under No 416
Lent by Islington Libraries

This painting of a she-wolf at bay, fiercely facing a group of hunters who cower in the woods behind, is a symbolic representation of Miss Ffrangcon-Davies in the character of *La Louve*, Isabella of France in Marlowe's *Edward II* (see Nos 41,50).

44
Variation on 'Othello' c1932-4
Oil on canvas; 44 × 29 (112 × 73.5)
signed 'Sickert' b.l.
First exhibited: Leicester Galleries 1934 (6)
Literature: Browse 1960, p 91
Lent by the City of Bristol Museum and Art Gallery

The full title of the painting as catalogued in the Leicester Galleries exhibition identified the actors: Ira Aldridge as Othello, Valerie Tudor as Desdemona and Gastrolle as Cassio. These identifications suggest the painting may be a 'Variation' of extraordinary perversity, because Ira Aldridge was a negro actor of the 1830s while Valerie Tudor was an actress of the 1930s (and later) whom Sickert often portrayed in Old Vic productions (see notes to Nos 40,46). Gastrolle has not, so far, been placed. More perplexing still, Desdemona is not one of the many Shakespearian roles known to have been played by Valerie Tudor. Thus, the whole painting seems to be an imaginary concoction. The composition may have been based on a photograph of a contemporary production, or on an engraving of a past one, with Sickert superimposing portrait heads of his chosen actors at will.

45
Her Majesty's c1933
Oil on canvas; 23½ × 25½ (60 × 65)
signed 'Sickert' b.r. and inscribed 'Her Majesty's' b.l.
First exhibited: Leicester Galleries 1934 (9)
Literature: Browse 1960, p 107
Lent by the Visitors of the Ashmolean Museum

One of a few late theatre paintings by Sickert in which the whole proscenium is represented, with no particular focus on one or more actors. It is possible that the painting does not show a contemporary production but is instead an 'Echo' based on an earlier black-and-white illustration.

46
Peggy Ashcroft as Miss Hardcastle in She Stoops to Conquer 1933-4
Oil on canvas; 49¾ × 27¾ (126.5 × 70.5)
inscribed 'PEGGY ASHCROFT AS/MISS HARDCASTLE' across lower edge
First exhibited: Leicester Galleries 1934 (3)
Literature: Baron, p 385, No 424
Lent by a Private Collector

Peggy Ashcroft, in a broadcast discussion between several of Sickert's friends transmitted on the Home Service of the BBC in February 1961, recalled this painting as an illustration of the way Sickert 'would suddenly see something in a scene which, to him, was very pictorial. . . . In *She Stoops to Conquer* it was rather – it wasn't a very impressive set. It was a good Old Vic setting, you know, and it had a staircase at the back, and the line: Would it were bedtime, and all were well, and I went up the staircase at the back. And he painted an enormous picture of this bare, large backcloth and the staircase and a tiny figure going up the stairs. Well, what precisely it was that appealed to him at that moment I don't know.' When the painting was exhibited at the Leicester Galleries in 1934 the line quoted by Dame Peggy was given in the title. The production of Goldsmith's play at the Old Vic ran from December 1932

until May 1933. Sickert produced several paintings of different scenes in this production, all featuring Peggy Ashcroft and some including Valerie Tudor as Miss Neville.

47
The Divine Peggy – Lady Teazle c1933-4
Oil on canvas: 50 × 24 (127 × 61)
signed 'Sickert' b.l. and inscribed 'THE DIVINE PEGGY – LADY TEAZLE'
First exhibited: London Group, November 1933 (13)
Lent by the South Eastern Electricity Board

Peggy Ashcroft played Lady Teazle in Sheridan's *The School for Scandal* at the old Vic in 1933.
In the broadcast discussion transmitted on the BBC in 1961 (see Note to No 46) Peggy Ashcroft remembered this 'most curious picture of me as Lady Teazle, in which I am just a figure right on the footlights, complete distortion, and this was obviously what interested him. I'm almost a blank.'

48
Peggy Ashcroft and Nancy Price in 'The Life that I gave Him'
Oil on canvas; 42 × 27 (106.5 × 68.5)
Lent by a Private Collector

Pirandello's play, with Peggy Ashcroft in the part of Lucia Maubelin, was performed at the Little Theatre in October 1934.

49
Juliet and her Nurse 1935-6
Oil on canvas; 30 × 25 (76 × 63.5)
signed 'Sickert' b.l.
First exhibited: Leicester Galleries 1936 (53) as *Edith Evans and Peggy Ashcroft in 'Romeo and Juliet'*
Literature: Browse 1960, p 93; Baron, pp 176,384,No 418,Fig 292
Lent by Leeds City Art Galleries

Edith Evans as the nurse and Peggy Ashcroft as Juliet in a production of Shakespeare's *Romeo and Juliet* performed at the New Theatre from October 1935 until March 1936. The painting was exhibited in April 1936 and several press photographs confirm that it was the picture now in Leeds. Leeds Art Gallery acquired the painting in 1937.

50
Gwen Again c1935-6
Oil on canvas; 56¼ × 40 (143 × 101.5)
signed and inscribed 'Sickert – St Peter's-in-Thanet' b.l. and 'L'Oltraggio che scende sul capo d'un re/ imobil mi rende, tremolo mi fe' across top edge
First exhibited: Leicester Galleries 1936 (49)
Literature: Baron, pp 176,383,385, No 425
Lent by a Private Collector

The inscription ('The insult which befalls a king renders me insensible, makes me tremble') must refer to the character and deeds of Isabella of France, the part Gwen Ffrangcon-Davies is portrayed playing in Marlowe's *Edward II* (see also No 41). The St Peter's incription and its exhibition in April 1936 fixes the limits of this painting's date-bracket.

51

Peggy Ashcroft and Paul Robeson in Othello c1935-6
Oil on canvas; 38 × 20 (96.5 × 51)
unsigned
First exhibited: Leicester Galleries 1936 (55)
Literature: Baron, pp 176,383,No 417, Fig 293
Lent by Mrs Constance J W Fettes

Shakespeare's *Othello* starring Peggy Ashcroft as Desdemona and
Paul Robeson as Othello opened at the Savoy Theatre, London in
May 1930. However, the dramatic, glowing colour of this painting
suggests it is close in date to *Gwen Again* (No 50).

52

The Taming of the Shrew c1937
Oil on canvas; 39½ × 24 (100.5 × 61)
signed 'Sickert' t.r.
First exhibited: Leicester Galleries 1938 (7)
Literature: Browse 1960,p 91; Baron, pp 176,384,No 419,Fig 294
Lent by Bradford Art Galleries and Museums

The 1938 Leicester Galleries exhibition catalogue identified the
actors portrayed in this painting. Edith Evans is represented as
Katherine and Leslie Banks as Petruchio in a production of
Shakespeare's *The Taming of the Shrew* at the New Theatre in
March 1937.

53

The Taming of the Shrew 1937
Oil on canvas: 23¾ × 19¾ (60.5 × 50)
unsigned
First exhibited: probably Leicester Galleries 1938 (10)
Lent by Dr and Mrs Colin Phipps

Another scene in the production of the play at the New Theatre in
March 1937 (see No 52) with Edith Evans as Katherine and Leslie
Banks as Petruchio.

54

Jack and Jill 1936-8
Oil on canvas; 24½ × 29½ (62 × 75)
signed 'Sickert' b.r.
First exhibited: Leicester Galleries 1938 (17)
Lent by a Private Collector

Shortly before the First World War Sickert had painted a music hall
interior during the screening of a cinematograph presentation, but
Jack and Jill is unique as a close-up representation of identifiable
stars in an actual film. It shows Edward G Robinson and Joan
Blondell in *Bullets and Ballots* of 1936. The painting may have been
done from a publicity still. Certainly the two stars never appeared
together in exactly the pose of this painting in the film as screened
on television in February 1980. The painting formerly belonged to
Edward G Robinson who discovered it in the Kaplan Gallery
shortly after the Second World War.

55

A Theatrical Incident: As You Like It 1938
Oil on canvas; 39¼ × 35½ (99.5 × 90)
signed 'Sickert' b.l.
First exhibited: Leicester Galleries June 1942, 'Retrospective

Collection of Drawings and Recent Paintings by Walter Richard
Sickert' (115)
Literature: Baron,p 385 under No 423
Lent by a Private Collector

Sickert had painted Peggy Ashcroft as Rosalind in the Old Vic
production of *As You Like It* in 1932 (see No 40). However, the
catalogue of the 1942 Leicester Galleries exhibition quoted the date
of this painting as 1938 and listed it under the title *Marie Ney as
'Celia' and Edith Evans as 'Rosalind'*. The production of the play
featuring these actresses was at the New Theatre in February 1937.

56

Sir Thomas Beecham Conducting 1938
Oil on burlap; 38¾ × 41⅛ (98.5 × 104.5)
signed 'Sickert' b.r.
First exhibited: Carnegie Institute, Pittsburgh 1939, 'International
Exhibition of Paintings' (153)
Literature: Browse 1960,pp 21,41,83,115, Pl 95; Baron,
pp 168,169,175,176,382,No 412, Fig 289
Lent by The Museum of Modern Art, New York, Bertram F and
Susie Brummer Foundation Fund, 1955

There is no record that Sir Thomas Beecham, Bt (1879-1961), the
conductor, composer, operatic impressario and founder of the
London Philharmonic Orchestra, gave Sickert any sittings or even
knew the artist was creating this superb image of him in action. The
date of the painting is established by a letter from Sickert to Irene
Scharrer, postmarked 15 March 1938, in which he noted: 'I am at
work on dear Beecham conducting'.

57

High-Steppers c1938-9
Oil on canvas; 52 × 48¼ (132 × 122.5)
signed 'Sickert' b.l.
First exhibited: Leicester Galleries 1940 (8)
Literature: Browse 1960,p 83; Baron, pp 175,384 under No 420
Lent by the Scottish National Gallery of Modern Art

A late revival of the theme Sickert had tackled ten years previously
(see No 38). David Cottingham of the Hulton Picture Library has
established that the chorus line is once again the Plaza Tiller Girls,
dressed in the costumes they wore in 'Up with the Lark' performed
at the Adelphi Theatre in 1927.

58

Mr Maxton as Hamlet
Oil on canvas; 32¼ × 14⅜ (82 × 36.5)
signed 'Sickert' b.c.
First exhibited: Leicester Galleries 1940 (4)
Lent by the Government Art Collection

Eric Maxton's career is not well-documented, and the date and place
of the production of *Hamlet* in which he took the title role has not
yet been established. It is possible that he played the part in the
provinces, perhaps even in Bath where Sickert could have seen his
performance.

Echoes

The 'Echoes' were a new invention of Sickert's late years. The term itself was first used by Sickert as the subtitle to *La Traviata* (No 60, one of the earliest paintings in this genre), when it was exhibited at the Savile Gallery in February 1928 as *An Echo of Sir John Gilbert, RA*. Sickert's choice of the word 'Echo' was thereafter adopted to describe all his paintings, both subject pictures and portraits, based on Victorian documents.

Nostalgia for the Victorian age of his boyhood must have inspired Sickert to create, from black-and-white originals, his very individual evocations of the life and humour of that time. His profound admiration for the Victorian illustrators had been nurtured since childhood because his father, Oswald Adalbert Sickert, was himself a well-known illustrator whose woodcuts featured regularly in the Munich newspapers.

In a revealing letter written in 1931 when the Leicester Art Gallery bought *The Bart and the Bums* (No 67), another Echo after Gilbert, Sickert explained the motivation behind this painting in particular and the Echoes in general. Having recalled his early commission from the *Pall Mall Budget* to make a portrait drawing of Sir John Gilbert (published 13 April 1893), Sickert continued:

I little thought I should be the humble instrument of drawing public attention to the interest of a rigorous and 'populacier' composition by that great artist. The drawing illustrated a story in the London Journal, the literary merit of which story is not sufficient to attract permanent interest to the illustrations.

The design would have remained buried for ever if I had not felt inspired to translate it into a painting. Claiming thereby the same liberty as Pope or Butcher & Lang or Schlegel claim with Homer, Virgil with Homer, Fitzgerald in the Omar Khayyam &c.

I confess also to a desire to do a little propaganda by sending the younger painters to rifle the wealth of English sources of inspiration.

Thousands who will see this low-comedy design would not have seen it but for
John Gilbert who inv. et del.
Gorway who sculpst.
& me who have had the temerity to retrace in paint the admired monogram JG.

[I am indebted to the Leicestershire Museums, Art Galleries and Records Service for sending me a copy of this letter.]

Sickert used the Victorian designs only as spring-boards. He did not, as it were, hand-colour a black-and-white print, but instead translated the originals, with evident verve and enjoyment, into full, modelled, atmospheric colour. The themes varied according to the interests of the authors of the original designs: landscapes after Fransesco Sargent (Nos 65,72,78,81); opulent and romantic idylls after Kenny Meadows (Nos 76,83) and Adelaide Claxton (No 86); sentiment, romance, but often more trenchant comment on social *mores* and comic situations after John Gilbert (Nos, 60,61,66,67, 69,73,74,77,80,84,85); and comic caricature again after Georgie Bowers (Nos 68,70).

When, in May 1931, the Leicester Galleries put on the first exhibition devoted to Sickert's 'English Echoes', the artist published notes on 'The Sources' as an appendix to the catalogue. These are reprinted below:

JOHN GILBERT, born at Blackheath in 1817, draughtsman on wood, *Illustrated London News, London Journal*, etc. He was best known for his illustrations of Shakespeare. It is probable that he will be ultimately remembered by his smaller cuts in the *London Journal* and other periodicals, where he was master of romantic and melodramatic subjects, and could move more freely in ground that had not been stereotyped by the theatre. His pencil shone with equal facility in low-life, colonial subjects, and in dazzling saloons of the aristocracy.

FRANSESCO SARGENT, draughtsman on wood for many years around the 'fifties on the staff of the famous *London Journal*. His collaboration with Gorway as engraver, resulted in an output which, for quality, vivacity, and variety, has probably never been equalled. He treated contemporary history, landscape, marine

subjects and architecture with equal brilliance and facility.

KENNY MEADOWS was the Nestor, so to speak, of the *Punch* staff, which he joined at the age of fifty-one, with thirty years still before him. He will probably be best known by his illustrations of Byron, with whose delightful brand of flippant and inspired vulgarity he was fitted with precision to identify his pencil.

'GEORGIE BOWERS', born in London in 1836, her father, the late Dean of Manchester, being Rector of St Paul's, Covent Garden. She was trained at the Manchester School of Art. She was indebted to the engraver, Swain, for sympathy and advice. She drew for *Punch,* the *Graphic,* the *Illustrated Sporting and Dramatic.* She lived on horse-back with her sketch-book in her saddle pocket. She worked eight hours a day and never took a holiday. She had the most exquisite figure on record, as may be seen from her photograph in Mr Spielmann's History of *Punch.*

ALFRED BRYAN. To the translator it seems impossible that Alfred Bryan should need a biographical note. Was not the window in Wellington Street of the *Entr'acte* Office the paradise of the art-lover in London for more years than can be counted? And the pages of the *Era* that illustrated 'The Captious Critic'? And the little paper called *Moonshine?* Who but Alfred Bryan had the proper formula for Irving, for Ellen Terry, for Randolph Churchill, for Salisbury, for Parnell or for Spencer!

ADELAIDE CLAXTON was born in Southampton Street, Fitzroy Square, the daughter of Marshall Claxton, an artist of note. She studied at Mr. Cary's School of Art in Bloomsbury. She contributed every week to *Judy, Bow Bells,* London *Society* and other periodicals. She married in 1874, Mr. George Gordon Turner, second son of the Rev. G.H. Turner, Rector of Deopham, Norfolk, and Berkeley Chapel, Mayfair. She was obliged to make thirteen replicas of her picture entitled 'Little Nell'.

The Echoes were immediately popular, an effect reflected in the very early purchase dates of several examples in public collections. Indeed, even the Louvre bought an Echo in 1932, *Hamlet* after John Gilbert (now in the Musée National d'Art Moderne). Sickert's dealers throughout the 1930s, in particular the Leicester Galleries and the Beaux Arts Gallery, were eager to exhibit nearly every Echo he painted, usually very soon after its completion. The dates of these exhibitions thus serve as a fairly accurate guide to the chronology of the paintings, and their catalogues often identify Sickert's Victorian sources.

59
Suisque Praesidium c1927
Oil on canvas; circular, diameter 35 (89)
inscribed 'Anon. del' b.l. and 'SUISQUE PRAESIDIUM' around lower edge
First exhibited: Savile Gallery 1928 (14)
Literature: Baron, pp 172,386,No 429
Lent by a Private Collector

Probably Sickert's first Echo. Robert Emmons, Sickert's biographer and pupil at this period, recorded that an Echo done from a pot lid was the first of the series. The design of *Suisque Praesidium* ('protector of his own'), depicting a Highlander's farewell to his family as he goes off to battle, was taken from a pomade pot. The owner of the painting told me that it was once gaily coloured, but that Sickert later decided to turn it into a virtual monochrome by painting over it in grey-blue. Traces of the original colour now grin through this upper coat of paint.

60
La Traviata c1927-8
Oil on canvas; 16½ × 24 (42 × 61)
inscribed 'J. Gilbert inv et del. Gorway sc.' b.l. and 'Sickert transcripsit' b.r.
First exhibited: Savile Gallery 1928 (2)
Lent by the Belgrave Gallery, London

Sickert first coined the term 'Echo' in relation to this painting, one of his earliest exercises in the genre (see prefatory note). He also deliberately underlined the inspiration and derivation of his work by revealing his sources in full, even including in his inscription the name of the engraver of Sir John Gilbert's design.

61
A Nativity c1929-30
Oil on canvas; 15¼ × 22 (38 × 56)
inscribed 'After John Gilbert' b.l., 'A nativity' b.c., and 'Sickert transcripsit' b.r.
First exhibited: Savile Gallery 1930 (3)
Literature: Baron, pp 178,386, No 430
Lent by a Private Collector

This Echo was reproduced, *Studio,* May 1930, p 368, together with Gilbert's original.

62
O it's nice to be beside the Seaside c1929-30
Oil on canvas; 25 × 21 (63.5 × 53.5)
unsigned
First exhibited: Savile Gallery 1930 (29)
Lent by a Private Collector

An Echo after H French.

63
The Beautiful Mrs Swears 1930
Oil on canvas; 14½ × 23½ (37 × 59.5)
signed and dated 'Sickert – 1930' b.r.
First exhibited: Leicester Galleries 1931 (16)
Literature: Baron, pp 172,386, No 432
Lent by a Private Collector

Sickert took his design from an anonymous engraving. Robert Emmons, Sickert's biographer, reported that Mrs Swears was the beauty of the season at Lowestoft, whom Sickert had admired when he visited the resort with his family as a boy. The painting has inspired the following poem by Bryan Guinness (Lord Moyne):

The sea is blinding blue,
The cliffs a flash of light,
And high above the world
Sits the lovely Mrs Swears;
And Edgar drops the book
To have a look.

She sits demurely at her needlework,
Her skirt spread round her on the grass,
A pom-pom on her hat.
She has a patient listening air:
Edgar had said he'd read
Indeed.

'My voice is rawther tired,' he says,
As he lets fall the book;
His lanky legs sprawl on the grass;
His arm props up his whiskered head.
'And what's a walk
Without talk?'

'We must be going home,' she says;
'We'll talk another day';
Her eyes are on her work,
As she bites off the thread.
But Edgar lies and stares
At lovely Mrs Swears.

Fido lies against her dress,
But Edgar keeps away;
He dare not come too close,
Though faithful as the dog.
He wonders if she would resent
A little compliment.

'Your nose is beautiful,' he says;
He cannot hold his tongue,
But dares not name her eyes.
She answers rising to her feet:
'I don't like personal remarks,'
And Fido barks.

64
The Tichborne Claimant c1930
Oil on canvas; 20 × 24 (51 × 61)
signed 'Sickert' b.l.
First exhibited: London Group October 1930 (121) as *The Claimant*
Literature: Browse 1960, p 109; Baron, pp 173,386,No 431
Lent by Southampton Art Gallery

Many of Sickert's Echoes were portraits of Victorian personages rather than subject pictures. This portrait of Arthur Orton, the Tichborne Claimant, was painted from a photograph, taken in Paris in the 1860s by Mayor Frères, which belonged to Sickert. Sickert held strong views, expressed in letters to the press (eg *Daily Telegraph*, 15 March 1935, *Sunday Times*, 22 March 1936), on the Victorian *cause célèbre* whereby Arthur Orton claimed to be Sir Roger Tichborne and heir to a considerable fortune.

65
Frisco c1930
Oil on canvas; 15½ × 27½ (39.5 × 70)
signed 'Sickert' b.r. and inscribed ꞌFRISCOꞌ b.l.
First exhibited: Leicester Galleries 1931 (20)
Lent by Mrs Kathleen Fisher

After Francesco Sargent. A press cutting suggests *Frisco* may have been exhibited at the Grafton Galleries in June 1930.

66
Study for 'Glencora' c1930
Oil on canvas; 17 × 29½ (43 × 75)
unsigned
First exhibited: Leicester Galleries 1931 (17)
Lent by Odin's Restaurant

Exhibited as a study for *Glencora* at the Leicester Galleries in 1931, together with the more finished version after an original by John Gilbert.

67
The Bart and the Bums c1930
Oil on canvas; 23½ × 25 (59.5 × 63.5)
signed 'Sickert' b.l. and inscribed 'after JG' (in monogram) b.r.
First exhibited: Leicester Galleries 1931 (4)
Literature: Browse 1960 p 94
Lent by Leicestershire Museums and Art Galleries

See the prefatory note for Sickert's letter, written when Leicester purchased this Echo in 1931. The JG in monogram is a copy of that used by Gilbert himself.

68
The Private View at the RA c1930
Oil on canvas; 20 × 30 (51 × 76)
signed 'Sickert' b.r. and inscribed 'After Georgie Bowers' b.l.
First exhibited: Leicester Galleries 1931 (9)
Literature: Baron, pp 178,386,No 436
Lent by the Government Art Collection

One of two Echoes after Georgie Bowers representing the Royal Academy. The other (present whereabouts unknown) is inscribed 'to the dear and perpetual memory of Georgie Bowers. The R.A.'.

69
The Two Lags c1930-1
Oil on canvas; 18 × 30 (45.5 × 76)
signed 'Sickert' b.r. and inscribed 'After Gilbert' b.l.
First exhibited: Leicester Galleries 1931 (14)
Lent by the Belgrave Gallery, London

70
On Her Majesty's Service c1930-1
Oil on canvas; 17 × 26¾ (43 × 68)
signed and inscribed 'Sickert/ after/ Georgie Bowers' b.l.
First exhibited: Leicester Galleries 1931 (11)
Lent by a Private Collector

71
Vicinique Pecus c1930-1
Oil on canvas; 24 × 19 (61 × 48.5)
signed 'Sickert' b.r.
First exhibited: Leicester Galleries 1931 (l)
Literature: Baron, pp 178,386,No 435
Lent by a Private Collector

After Kenny Meadows. The title means 'the flock of a neighbour', a reference to the poaching intentions of the gentleman.

72
Dover c1931-2
Oil on canvas; 21 × 22½ (53.5 × 57)
signed 'Sickert' b.l.
First exhibited: Beaux Arts Gallery 1932 (5)
Literature: Browse 1960, p 94; Baron, pp 178,387, No 438
Lent by Leicestershire Museums and Art Galleries

After Francesco Sargent. This Echo formerly belonged to Hugh Walpole.

73
Summer Lightning c1931-2
Oil and pencil on canvas; 24⅝ × 28½ (62.5 × 72.5)
signed 'Sickert' b.r.
First exhibited: Beaux Arts Gallery 1932 (8)
Literature: Browse 1960, p 95; Baron, pp 178,387, No 440
Lent by the Walker Art Gallery, Liverpool

After John Gilbert's engraving, *The Unexpected Rencontre*. Sickert's Echo and Gilbert's engraving were reproduced together in the *Illustrated London News,* 9 April 1932.
This Echo was purchased by Liverpool in 1932.

74
Idyll c1931-2
Oil on canvas; 27 × 28½ (68.5 × 72.5)
signed 'Sickert' b.c.
First exhibited: Beaux Arts Gallery 1932 (3)
Literature: Browse 1960, p 93; Baron, pp 178,387, No 441
Lent by the Ferens Art Gallery, City of Kingston upon Hull

Another romantic and seductively coloured Echo after Gilbert. The *Illustrated London News,* 9 April 1932, published the painting together with its Victorian original, entitled *An Embarrassing Moment.* The Art Gallery purchased the painting in the same year.

75
Anne Sheepshanks c1931-2
Oil on canvas; 27½ × 17½ (70 × 44.5)
signed and inscribed across lower edge 'Anne Sheepshanks Walter Richard Sickert'
First exhibited: Beaux Arts Gallery 1932 (26)
Lent by a Private Collector

Exhibited in 1932 as *Portrait of the Painter's Godmother Anne Sheepshanks of Tavistock Place, London and London Road, Reading.* Miss Sheepshanks was the sister of the Rev Richard Sheepshanks (1794-1855), the distinguished astronomer who had given up the Church shortly before the birth, out of wedlock, of his daughter Eleanor in 1830. Eleanor, whose mother abandoned her as a child to emigrate to Australia, was Sickert's mother. Sheepshanks did not acknowledge Eleanor as his daughter, but passed himself off as her guardian, Miss Sheepshanks, however, took a more keen and benevolent interest in her natural niece and, after Eleanor's marriage to Oswald Sickert and their move from Munich to England, she had a hand in Walter Sickert's upbringing and generally helped the Sickert family to settle in London.
Sickert's portrait is here classed as an Echo because it was obviously painted from a Victorian document, probably a photograph.

76
Her Serene Highness c1931-2
Oil on canvas; 24 × 20 (61 × 51)
signed 'Sickert' t.r.
Lent by E Carew-Shaw, FRCS

There are two versions of this Echo after Kenny Meadows. The other version, signed 'Sickert pinxt' b.l. was exhibited at the Beaux Arts Gallery in 1932 (2) and reproduced in the catalogue.

77
The Wave c1931-2
Oil on canvas; 30 × 30 (76.2 × 76.2)
signed 'Sickert pinxt.' b.l.
First exhibited: Beaux Arts Gallery 1932 (14)
Literature: Browse 1960,p 110
Lent by the City Museum and Art Gallery, Stoke-on-Trent

After John Gilbert.

78
Fireworks on Primrose-Hill c1931-2
Oil on canvas; 30 × 18 (76.2 × 45.5)
First exhibited: Beaux Arts Gallery 1932 (9)
Lent by a Private Collector

An Echo after Francesco Sargent whose original woodcut depicted the fireworks to celebrate the taking of Sebastapol.

79
Sweet Prince c1931-2
Oil on canvas; 28 × 23¾ (71 × 60.5)
inscribed 'In grateful and precious memory of a friendship of half a century – Sickert' across lower edge
First exhibited: Beaux Arts Gallery 1932 (17)
Literature: Baron, pp 176,384, No 422
Lent by Mr and Mrs David Tomlinson

This Echo represents Sir Johnstone Forbes-Robertson (1853-1937) as Hamlet. Sickert gave and dedicated it to the famous actor-manager who had been a friend of the Sickert family since his youth. Hamlet was Johnstone Forbes-Robertson's most famous role. His production of the play at the Lyceum Theatre in 1897 was widely acclaimed, his farewell performances at Drury Lane in 1913 included Hamlet, and his final appearance on stage was in this part. Sickert perhaps used an old photograph, or possibly an Alfred Bryan illustration, to paint this testimony of friendship and admiration.

80
Woman's Sphere 1932
Oil on canvas; 27½ × 25 (70 × 63.5)
signed 'Sickert' b.l.
First exhibited: Beaux Arts Gallery 1932 (1)
Literature: Browse 1960, p 100
Lent by the Government Art Collection

After John Gilbert.

81
Grover's Island from Richmond Hill 1932
Oil on canvas; 22½ × 35 (57 × 89)
signed 'Sickert pinxt' b.c.
First exhibited: Beaux Arts Gallery 1933 (5)
Lent by R J Glazebrook, Esq.

This well-known view of the Thames was suggested to Sickert by a woodcut by Francesco Sargent.

82
The Empress Eugénie 1933
Oil on canvas; 46 × 35 (117 × 89)
First exhibited: Beaux Arts Gallery 1933 (1)
Lent by a Private Collector

According to the catalogue of the Beaux Arts Gallery exhibition, this equestrian portrait was suggested to Sickert by a painting by J L David and other contemporary (presumably French) portraits. The Empress Eugénie, who visited Dieppe with her husband Napoleon III in 1853, was responsible for the layout of the *plage* in the town which had been Sickert's second home. It was she who drew the elaborate plan of the broad seafront, with its winding paths and formal gardens, flanking the fine boulevard, named after the Marquis Aguado, features which still distinguish Dieppe.

83
Juan and Haidée c1930-4
Oil on canvas; 22 × 20½ (56 × 52)
unsigned
First exhibited: Leicester Galleries 1934 (17)
Lent by the City Museum and Art Gallery, Stoke-on-Trent

One of two versions of this Echo after Kenny Meadows. The other version, in the Government Art Collection, is dated 1930 and was exhibited at the Leicester Galleries in 1931 (10).

84
The Bush c1933-4
Oil on canvas; 27 × 25 (68.5 × 63.5)
signed 'Sickert' b.r. and inscribed 'The Bush' b.l.
First exhibited: Leicester Galleries 1934 (2)
Lent by a Private Collector

An Echo after John Gilbert.

85
The Boudoir c1933-4
Oil on canvas; 18 × 29½ (45.5 × 75)
signed 'Sickert' b.l.
First exhibited: Leicester Galleries 1934 (10)
Lent by a Private Collector

After John Gilbert.

86
Second Course, Mein Freund c1935
Oil on canvas; 22½ × 26½ (57 × 67.5)
inscribed '"Mein Freund" Sickert' b.r. and 'After "Adelaide" Claxton' b.l.
First exhibited: Leicester Galleries 1935, 'Summer Exhibition' (106)
Lent by a Private Collector

87
The Standard Theatre, Shoreditch (1844) c1935-6
Oil on canvas; 48 × 60 (122 × 152.5)
signed and inscribed 'Sickert 1844' b.l.
First exhibited: Leicester Galleries 1936 (44)
Lent by Dr Edwin Besterman, MA,MD,FRCP

The title given here is that used in the 1936 Leicester Galleries catalogue. However, Sickert based this Echo on an engraving published in the *Illustrated London News* in May 1845. The engraving commemorated the opening of the New Standard Theatre in Shoreditch. To quote the accompanying text, 'This little Temple of the Drama was erected a few months since, on the site of twelve houses, adjoining "the Standard Theatre," . . . The interior is of the horseshoe form, and a domed roof, a construction peculiarly well adapted for the transmission of sound. . . . The equestrian performances were the holiday novelty of Monday last: they are not given in the area of the auditory, but in the place of the stage; for which purpose the flooring is, by ingenious machinery, removed upon a kind of railway, the proscenium boxes are made to recede, and a ring is presented 39 feet in diameter, . . . Our illustration is a scene from an Equestrian Spectacle, . . . and entitled "The Conquest of Tartary; or, The Eagle Rider of Circassia, and her Monarch Steed of the Desert!" wherein a Mrs R. B. Taylor's

performance is very striking.' Sickert's painting accurately transcribes the detail as well as the general outline of the engraving, only departing from the original in his mistaken inscription of the date as 1844 instead of a year later.

88
Princess Pauline de Talleyrand-Perigord, Marquise de Castellane c1937
Oil on canvas; 50¼ × 35¼ (127.5 × 89.5)
signed 'Sickert' b.r. and inscribed 'PAULINE DE TALLEYRAND–PERIGORD/MARQUISE DE CASTELLANE' across top edge
First exhibited: Leicester Galleries 1938 (19)
Literature: Browse 1960, p 91
Lent by the Bolton Museum and Art Gallery

This portrait, based on a Victorian document, must be classed as an Echo. The family of Talleyrand-Perigord was ancient and distinguished. Comte Louis of that family was recorded by Proust as frequenting Dieppe during its fashionable heyday in the later nineteenth century, and perhaps therein lay the Sickert connection.

89
Sirens Aboard c1937
Oil on canvas; 30 × 19 (76 × 47.5)
signed 'Sickert' b.r. and inscribed 'J. S. Seccombe' b.l.
First exhibited: Leicester Galleries 1938 (20)
Literature: Browse 1943, p 33 and rep. in colour; Baron, p 385, No 427, Fig 295
Lent by a Private Collector

Mistakenly entitled *Sirens Abroad* in Baron. Sickert is not known to have used J S Seccombe as his source for any other Echo.

90
Evening c1938-9
Oil on canvas; 18 × 28 (46 × 71)
signed 'Sickert' b.r.
First exhibited: Leicester Galleries 1940 (14)
Literature: Baron, p 385, No 428, Fig 302
Lent by Kirkcaldy Art Gallery

The original of this Echo is unacknowledged.

91
The Venture c1938-9
Oil on canvas; 16 × 24 (40.5 × 61)
unsigned
Literature: Browse 1960, p 93
Lent by Leeds City Art Galleries

The original author of this design is unacknowledged. Nevertheless, Sickert painted this Echo in two versions, the other one being exhibited at the Leicester Galleries in 1940 (15) as *Landing from the Boat*. It was reproduced in the catalogue.

92
The Rectory 1939
Oil on canvas; 24¼ × 29¼ (61.5 × 74.5)
signed 'Sickert' b.r.
First exhibited: Leicester Galleries June 1942, 'Retrospective Collection of Drawings and Recent Paintings by Walter Richard Sickert' (106).
Lent by a Private Collector

The source of this Echo is not known. The date 1939 was quoted in the Leicester Galleries exhibition held a few months after Sickert's death.

93
Queen Victoria and her Great-Grandchild c1940
Oil on canvas; 18 × 20 (45.5 × 51)
signed 'Sickert' b.l.
Lent by a Private Collector

The baby in this Echo, probably derived from a photograph, is said to be Edward, the future King Edward VIII and subsequently Duke of Windsor.

94
Temple Bar c1941
Oil on canvas; 27 × 30 (68.5 × 76)
unsigned
Lent by a Private Collector

Helen Lessore cites *Temple Bar* as Sickert's last painting. In a talk recorded in 1960 and transmitted on the Third Programme of the BBC in 1966, Mrs Lessore told how Sickert took the subject from an engraving which was in her possession. She went on: 'one can see if one compares it with the picture, oh, this is a cab, and so forth, but it's very difficult to see on the actual picture that certain things are cabs or whatever they are; in a curious way it looks rather like a very late Titian, but it's simply the shapes that have become so grand. I think this is one of the grandest pictures he ever painted.' In the present catalogue, Helen Lessore tells how Sickert re-emphasised the lines of squaring-up after their purpose had already been served. Temple Bar, Christopher Wren's great gateway to the City of London, was removed from its site (where it was held to obstruct traffic) in 1878 and re-erected in 1888 in Theobald's Park. Sickert evidently painted from an engraving representing Temple Bar before its rural exile.

Figure subjects

Sickert's interest in anecdotal figure subjects was largely diverted during the late period into his Echoes. Press photographs occasionally afforded him subjects of contemporary human interest (eg Nos 97,98), although as documents of real, in contrast to imagined, situations these paintings are distinct in effect and intention from his earlier, personally conceived and contrived figure subjects. A reflection of his earlier approach is, however, contained in two late paintings (Nos 99,100) based on a drawing of the Camden Town period.

95
The Area Steps c1928
Oil on canvas; 22 × 17 (56 × 43)
signed 'Sickert' b.r.
First exhibited: Savile Gallery 1930 (2)
Lent by M V B Hill, Esq.

This painting, of a young girl glimpsed through the railings in front of the basement of an Islington terrace house, has possessed a bewildering number of titles. It was exhibited in the Sickert retrospective held at the National Gallery in 1941 (96) as *Angel Basement* or *Evening Primrose*. A smaller painting entitled *The Evening Primrose* (12 × 16½ inches) was included (No 5) in the same Savile Gallery exhibition of 1930 from which the present owner purchased *The Area Steps*. This smaller painting is now of unknown whereabouts but it is possible that it represented a subject similar to *The Area Steps* so that the more poetic title was also adopted for the larger painting here exhibited. The owner, in a letter to the Arts Council, has explained how his painting came to be called *Angel Basement*. This title was given to the painting by Geoffrey Toye, the conductor, who adapted it from the title of J B Priestley's novel *Angel Pavement*, published in 1930.

96
Wed 1931-2
Oil on canvas; 24 × 20 (61 × 51)
First exhibited: Beaux Arts Gallery 1932 (23)
Lent by a Private Collector

One of several paintings of the 1930s, painted from photographs, on the theme of weddings (see also No 102).

97
Miss Earhart's Arrival 1932
Oil on canvas; 27 × 72 (68.5 × 183)
signed 'Sickert' b.r.
First exhibited: Carnegie Institute, Pittsburgh 1933, 'International Exhibition of Paintings' (150)
Lent by a Private Collector

The first exhibition of this painting in the United States was appropriate because it represents the American Amelia Earhart (1898-1937) arriving in Britain in May 1932 having made the first solo flight by a woman across the Atlantic. Her success led to her making a series of even longer flights across the United States as she endeavoured to end male domination of aviation. In 1937 she set out to fly a US navigation-plane around the world and mysteriously disappeared.

98
The Miner 1935-6
Oil on canvas; 50¼ × 30⅛ (127.5 × 76.5)
unsigned
First exhibited: Leicester Galleries 1936 (54) as *Black and White*
Literature: Browse 1960, p 91; Baron, pp 175,176,382,No 410, Fig 290
Lent by Birmingham Museums and Art Gallery

The subject-matter of this painting is unique during a decade when Sickert's figure pictures either harked back to the Victorian era or reflected colourful contemporary events such as weddings (Nos 96,102) or *Miss Earhart's Arrival* (No 97). *The Miner* was shown at the Carnegie Institute, Pittsburgh International Exhibition of 1936 (109) under its present title but contemporary press reviews prove that *Black-and-White* shown at the Leicester Galleries earlier in the year was the same picture. The subject was identified in the press as representing the re-union of a miner and his wife after his return to the pit-head after a stay-down strike. It is tempting to interpret the painting as an indictment of social injustice during the Depression. However, while Sickert clearly sympathised with the human side of the situation ('You'd kiss your wife like that if you'd just come up from the pit, wouldn't you?', he demanded, when he caught Denton Welch examining the painting), it is doubtful whether the artist intended to make a political statement. He was more probably moved to paint the subject by the bold design of the press photograph upon which he based his work.

99
My Awful Dad c1936-8
Oil on canvas; 27 × 20 (68.5 × 51)
unsigned
Literature: Baron, pp 126,177,361,382 under No 411
Lent by a Private Collector

This squared-up, grisaille sketch and the more finished *Hubby* (No 100) are rare examples of paintings of the 1930s based on drawings. However, Sickert's preparatory documents were not of recent execution, but were works of about 1912 which the artist must have rediscovered in his studio. The paintings are particularly close in composition to the chalk drawing in the Ashmolean Museum, Oxford (rep Baron, Fig 235). It is uncertain whether Sickert worked

directly from this particular drawing of 1912, which is not squared-up, or from another working study of the same subject. The title, *My Awful Dad,* is derived from the inscription on a chalk drawing in the Courtauld Institute of Art Collection which is itself related to the Ashmolean Museum drawing. The man seated in the background with his feet on a stool is Hubby, Sickert's general factotum and model between 1911 and 1914.

100
Hubby c1936-8
Oil on canvas; 27⅜ × 20½ (69.5 × 52)
signed 'Sickert' t.r.
First exhibited: Leicester Galleries 1938 (11)
Literature: Baron, pp 126,177,361,382, No 411, Fig 291
Lent by a Private Collector

See note to No 99.

101
The Coffee Mill c1936-8
Oil on canvas; 30 × 30 (76 × 76)
signed 'Sickert' b.l.
First exhibited: Leicester Galleries 1938 (16)
Lent by a Private Collector

The exhibition of this painting in 1938 proves it represents the kitchen of Sickert's house in St Peter's-in-Thanet, rather than at Bathampton as has been suggested. The interior and composition are the same as in *A Domestic Bully* (No 5), but the self-portrait and the seated female figure in the background are omitted from *The Coffee Mill.*

102
Pimlico c1937-8
Oil on canvas; 25⅛ × 30 (63.5 × 76)
signed 'Sickert' b.r.
Literature: Browse 1960, p 111
Lent by Aberdeen Art Gallery and Museums

This painting was purchased from the Adams Gallery in 1938. It was not included in the exhibition 'Sickert and the Living French Painters' held at that gallery from January to February 1937.

Landscapes

Landscape, and in particular townscape, had always been one of Sickert's major interests. His paintings of the Normandy port which, for much of his life, was his second home earned him the title of the Canaletto of Dieppe. His views of Venice, the outcome of several visits between 1895 and 1904, are among the most impressive and magnificent records of this much-painted city produced since Turner's death. Paradoxically, he seldom painted the streets and buildings of London. He tended to tackle landscape during the summer months when he usually left London. Indeed, English landscapes rarely featured in his production until the First World War prevented his annual excursion to Dieppe. He then found a congenial refuge during the summer in Bath, and discovered new subject-matter in Pulteney Bridge and the ordered architecture of Regency streets and crescents.

As soon as possible after the war ended Sickert moved from England to Envermeu, outside Dieppe, intending to settle there permanently. However, in 1922, his wife Christine having died two years before, he returned to London and never again left England except for fleeting visits abroad.

As he grew older, he found subjects for painting within a more restricted and accessible geographical range. Thus, while living in Islington, he painted a series of views of the terraced houses and gardens backing onto the Canal along Noel Street where he had a studio. Similarly, when he lived in St Peter's-in-Thanet from December 1934 until December 1938, and in Bathampton from December 1938 until his death, many of his landscapes depicted his own house and garden. The self-portraits, included as an incidental detail in several of these paintings (eg Nos 5-8), serve to underline their intimate, domestic inspiration. However, Sickert's habit of painting from a variety of source documents also gave him the facility to explore subject-matter less close at hand. Thus, using old photographs, engravings and his own earlier studies, he could express his nostalgic recol-

lections of Venice (Nos 110,111), of Paris (No 106) and of Dieppe (No 107). And, despite his age and relative immobility at Bathampton, Thérèse Lessore's photographs enabled him to record the contemporary aspect of nearby Bath (Nos 113,116-9), with pre-war cars and the newly introduced Belisha beacons punctuating the regulated vistas he had first painted over twenty years before.

103
Easter c1928
Oil on canvas; 26 × 30⅜ (66 × 77)
signed 'Sickert' t.r.
First exhibited: Royal Society of British Artists 1928 (243)
Literature: Browse 1960, p 111
Lent by the Ulster Museum, Belfast

The windows of Dawson Bros are filled with Easter bonnets, hence the title of the painting. The picture was exhibited at the RBA in the autumn and was probably painted earlier in that year. Dawson Bros was perhaps an outfitters in the Caledonian Road area. Another shop front of about this date, *Barnsbury*, is in the Glasgow Art Gallery but was not lent to the exhibition. *Barnsbury* certainly represents a Caledonian Road subject but was painted from an old photograph. *Easter* is more probably a contemporary scene. It is interesting that in these paintings Sickert returned to subject-matter he had tackled at the outset of his career in emulation of his master, Whistler.
The Ulster Museum purchased *Easter* from the Savile Gallery in 1929.

104
Barnet Fair 1930
Oil on canvas; 30 × 25 (76 × 63.5)
signed and dated 'Sickert '30' b.l.
First exhibited: Hull 1936, 'Spring Exhibition'
Literature: Browse 1960, p 107
Lent by Oldham Art Gallery

This painting was bought by Oldham Art Gallery in 1936 from a private collector who presumably bought it directly from the artist. It was not included in any of the one-man Sickert exhibitions organised by his dealers to show his recent work to the public. Oldham, however, lent it to the Sickert exhibitions held at the Arts Club of Chicago and the Carnegie Institute, Pittsburgh, in 1938. Sickert painted three views of Barnet Fair around 1930, each completely different in composition. The painting exhibited at R E A Wilson's Gallery in 1933 as *The Last of Barnet Fair* (11) is probably the version formerly in Sir Walter Fletcher's collection and now of unknown whereabouts. It shows the landscape deserted after the fair except for a gypsy and a string of horses. In contrast to the close-up focus on a horse and its handlers chosen by the artist for the Oldham painting, the alternative view exhibited here as No 105 provides a broad prospect of the scene.

105
Barnet Fair c1930
Oil on canvas; 27 × 28 (68.5 × 71)
signed 'Sickert' b.l.
Lent by Frost & Reed Ltd.

See note to No 104.

106
The Third Republic 1932-3
Oil on canvas; 30 × 22½ (76 × 57)
signed 'Sickert' b.l.
First exhibited: Beaux Arts Gallery 1933 (2)
Lent by Peterborough Art Gallery

The subject is La Porte St Denis, Paris, a scene which Sickert repeatedly painted with variations during the early 1930s. He presumably worked from photographs. The Phillips Art Gallery in Washington owns two more paintings of the subject, one entitled *Paris* and dated 1932 when exhibited at the Beaux Arts Gallery in 1933 (3), the other entitled *Ludovico Magno*, also dated 1932 in the 1933 catalogue (4). A fourth painting of La Porte St Denis is in a private collection. It is also probable that Sickert painted an Echo of the subject in Victorian times, because the painting entitled *'48* after Francesco Sargent (unknown whereabouts) is thought to represent La Porte St Denis in 1848.

107
La Rue du Mortier d'Or c1932-4
Oil on canvas; 32 × 32 (81.5 × 81.5)
signed 'Sickert' b.r.
First exhibited: Leicester Galleries 1934 (1)
Lent by a Private Collector

Apart from brief visits on business of one kind or another, Sickert never returned to Dieppe after 1922. This painting is a late, nostalgic recollection of one of his favourite sites in Dieppe, painted from photographs and/or earlier studies. In style it recalls the 'Echoes', but in this case the echoes came not from Victorian black-and-white illustrations but from Sickert's own past.

108
'All We Like Sheep . . .' c1936-8
Oil on canvas;
signed 'Sickert' b.l.
First exhibited: Leicester Galleries 1938 (4)
Lent by a Private Collector

Animal painting is a genre Sickert seldom tackled and this work is unique in subject. It was probably painted from a snapshot taken by Sickert or Thérèse Lessore, perhaps when they happened to come across a flock of sheep in the Broadstairs area. The title is taken from *Isaiah*, LIII, 6: 'All we like sheep have gone astray'.

109
91 Albion Road c1937-8
Oil on canvas; 24½ × 19½ (61.5 × 49)
signed 'Sickert' b.l.
First exhibited: Leicester Galleries 1940 (3)
Lent by a Private Collector

A Broadstairs subject painted while Sickert lived in St Peter's-in-Thanet between December 1934 and December 1938, probably towards the end of this period.

110
Il Cannaregio c1937-8
Oil on canvas; 31⅛ × 36 (79 × 92)
signed 'Sickert' mid b.r. and inscribed 'Canaregio' (*sic*) b.r.
First exhibited: Leicester Galleries 1938 (9)
Literature: Browse 1960, p 111; Baron, pp 177,388,No 449
Lent by Aberdeen Art Gallery and Museums

Although Sickert is not known to have visited Venice since 1904, except for a possible fleeting stay in 1930 (see Note to No 11), he painted this particular Venetian view three times in his later years (see also Nos 11,111). Perhaps he found an old photograph which especially appealed to him and awakened nostalgic memories of his former life in Venice. Certainly, the figures in this painting of the Cannaregio are not in contemporary dress, so that it may be regarded as an Echo rather than a true landscape.

111
Il Cannaregio c1938-40
Oil on canvas; 25 × 30 (63.5 × 76)
signed 'Sickert' b.r.
First exhibited: Leicester Galleries 1940 (ll)
Literature: Baron, pp 177,388 under No 449
Lent by Mrs Suzanne Paisner

See note to No 110

112
The Garden Window 1939
Oil on canvas; 34 × 26 (86.5 × 66)
signed 'Sickert' b.r.
First exhibited: Leicester Galleries 1940 (12)
Literature: Browse 1960, p 94 as *The Open Window*; Baron, pp 178, 387,388, No 451
Lent by Leeds City Art Galleries

This painting was exhibited in 1940 as *The Garden Window* and bought by the Leeds Art Gallery in that year. It has since acquired the alternative title. The garden is that of St George's Hill House, Bathampton, where Sickert lived from December 1938 until his death in January 1942. Many of his latest paintings are of the house and its gardens (see also Nos 114,115), and in several he included himself (see No 7) or his wife, Thérèse Lessore, as incidental figures. The figure at the open window in this painting is Thérèse Lessore. The garden is here shown in summer. The only summer between the date of Sickert's move to Bathampton and the exhibition of the painting in 1940 (April) was that of 1939.

113
Abbey Yard, Bath 1939-40
Oil on canvas; 25 × 30 (63.5 × 76)
signed 'Sickert' b.r.
First exhibited: Leicester Galleries 1940 (13)
Lent by the Government Art Collection

One of a sizeable group of Bath townscapes painted by Sickert during his last years in Bathampton from photographs, probably

taken by Thérèse Lessore. Most of these paintings are near monochromes, based on a range of greys, with only a few relieving touches of local colour. Other examples are exhibited and catalogued as Nos 116-119.

114
The Garden, St George's Hill House, Bathampton 1939-40
Oil on canvas; 34 × 27 (86.5 × 68.5)
signed 'Sickert' b.r.
Literature: Baron, pp 178,387, No 444, Fig 300
Lent by a Private Collector

The garden of Sickert's house in summer.

115
St George's Hill House, Bathampton 1939-40
Oil on canvas; 29 × 35 (73.5 × 89)
signed 'Sickert' b.r.
First exhibited: Leicester Galleries 1940 (10)
Lent by a Private Collector

Another view of the garden of Sickert's house, this time in winter.

116
The Vineyards, Bath 1941
Oil on canvas; 19½ × 27 (49.5 × 68.5)
signed 'Sickert' b.l.
First exhibited: Leicester Galleries 1942, 'Retrospective Collection of Drawings and Recent Paintings by Walter Richard Sickert' (118)
Literature: Baron, pp 177,387 under No 445
Lent by Mrs Constance J W Fettes

The date 1941 was given in the 1942 Leicester Galleries catalogue. This painting was confused by Baron with *Bladud Buildings*. There is another view by Sickert of *The Vineyards* showing a slightly different angle of the street, with a figure walking on the pavement in the right hand middle ground.

117
Bladud Buildings, Bath 1941
Oil on canvas; 21 × 31½ (53.5 × 80)
signed 'Sickert' b.r.
First exhibited: Leicester Galleries 1942, 'Retrospective Collection of Drawings and Recent Paintings by Walter Richard Sickert' (108)
Literature: Baron, pp 177,387, No 445, Fig 301 (wrongly entitled *The Vineyards, Bath*)
Lent by Mrs Constance J W Fettes

The date 1941 was given in the Leicester Galleries 1942 exhibition catalogue.

118
The Paragon, Bath 1941
Oil on canvas; 22 × 34 (56 × 86.5)
signed 'Sickert' b.l.
First exhibited: Leicester Galleries 1942, 'Retrospective Collection of Drawings and Recent Paintings by Walter Richard Sickert' (110)
Lent by N R E Miskin, Esq.

The date 1941 was given in the 1942 Leicester Galleries catalogue.

119
Walcot Parade, Bath 1941
Oil on canvas; 17½ × 32½ (44.5 × 82.5)
signed 'Sickert' b.r.
First exhibited: Leicester Galleries 1942, 'Retrospective Collection
of Drawings and Recent Paintings by Walter Richard Sickert' (114)
Lent by N R E Miskin, Esq.

The date 1941 was quoted in the 1942 Leicester Galleries catalogue.

120
A Scrubbing of the Doorstep 1941
Oil on canvas; 19½ × 23½ (49.5 × 59.5)
signed 'Sickert' b.r.
First exhibited: a version CEMA 1942 (30)
Literature: Baron, pp 178,388 under No 446
Lent by a Private Collector

There are two versions of this subject. The other version, rep Baron
Fig 299, was exhibited in the large Sickert retrospective held in
Leeds in 1942 and it is probable that it was this same version that
was included in the CEMA exhibition. The painting exhibited here
is rather more thinly and sketchily handled. However, both are close
in date. The version exhibited in Leeds was catalogued as having
been completed in November 1941, that is two months before
Sickert's death. The subject is again St George's Hill House.

121
Bathampton c1941
Oil on canvas; 25 × 30 (63.5 × 76)
unsigned
Lent by Mr and Mrs J G Glendinning

One of several paintings reputed to be Sickert's last painting (see
also Nos 37,94). This was, perhaps, Sickert's last landscape.

Photographs have been provided by the following:

Herbert Ballard
A C Cooper Ltd
The Courtauld Institute of Art
Prudence Cuming Associates Ltd
Studio Morgan
Sydney W Newbery
Tom Scott
Sotheby Parke Bernet

Back cover:
Portrait of Rear Admiral Lumsden CIE CVO